LEGACY IN TIME

LEGACY IN TIME

THREE GENERATIONS *of* MOUNTAIN PHOTOGRAPHY *in the* CANADIAN WEST

HENRY VAUX JR.

RMB

This volume is dedicated to members of the Vaux family –
past, present and future.

CONTENTS

FOREWORD

The legacy begins with a landscape so powerful that it captures one's imagination and spirit. It is given substance by the creativity and commitment of an extraordinary family and lives on through the preservation of an important and stunning collection of photographs. Henry Vaux Jr.'s rephotography project is a joyful and perceptive continuation of his family's remarkable contribution. With exacting images he traces the extremely dramatic glacial recession that first captivated his ancestors well over a century ago. With dedication and persistence he has steadfastly maintained the quest for scientific rigour with an aesthetic balance. Henry's perseverance and commitment are the stuff that legacy is made of.

The mountains of Western Canada were virtually unknown to tourism when the Vaux family, father and three children, first experienced this wilderness splendour. It was wilderness on the half-shell, however: wild and untrodden but nevertheless easily accessible by way of the new Canadian Pacific Railway and its chain of luxury hotels. The three Vaux siblings – George IX, William and Mary – were not only captivated by the scenic grandeur but also intrigued by the powerful entities that were the glaciers: solids that flow, vast masses of ice that grind rock to dust, a presence that not only forms the landscape but dominates it. The Vauxes' simple observation that the Illecillewaet Glacier had receded considerably since their previous visit only seven years before engaged the family in an ongoing study of glacial recession – the first exacting, precise record of glacial movement in North America.

As well-educated Quakers, the Vaux family were an example of the well-rounded Victorian: committed, inquisitive and dedicated to the advancement of man's understanding and appreciation of nature. As talented amateur artists and scientists as well, they fell under the spell of the Canadian Alps. Their dedication and commitment were spurred by what George Jr. described as "the consciousness that so little exploration has been carried out that each visitor is practically a new discoverer."

It was the age of the "amateur," in the original meaning of the term, as one who pursues an interest simply for the love of it. The word did not have negative connotations in those days. Intelligent, inquisitive minds were encouraged to create. It was considered one's highest function – if not duty – to contribute in any way possible to society. Emerging art forms such as photography and new investigations in earth sciences like geology were very much in the amateur's domain. Simple experiment and observation techniques could

lead to important advancements. William Vaux wrote of his Canadian glacier studies that "… every thing is so new and unknown the investigations will become doubly valuable from a scientific standpoint, and the student will have the satisfaction of knowing that he is treading in steps but seldom attempted by others…" There was an artistic influence as well. As talented amateur photographers, the three were actively involved in the Photographic Society of Philadelphia, and both George and Mary were associate members of Alfred Stieglitz's "Little Galleries of the Photo-Secession" at 291 Fifth Avenue in New York, simply called "291" and now considered hallowed ground by the photographic-history community.

The legacy continued with the next generation of the family donating this important collection to the Whyte Museum of the Canadian Rockies in Banff, Alberta. I had the good fortune to be the curator of photography at the museum at the time and consequently spent a great amount of energy in the early 1980s working intimately with this amazing collection. I wasn't alone in the effort; the entire Whyte Museum staff worked diligently not only to ensure the preservation of the material but also to turn it into an excellent research tool available to all. Our work culminated in an international touring exhibition of the family's stunning platinum prints, and a publication, *Legacy in Ice: The Vaux Family and the Canadian Alps*.

Over the ensuing thirty years the collection has been extensively used for both its documentary and its aesthetic value. Henry's project is another wonderful aspect of the vision, foresight and generosity of the multiple generations of this remarkable family that has ensured the survival of this important material and given substance to this significant legacy.

— Edward Cavell

PREFACE

A century is a long time for an individual or a family. People rarely live to be 100 and families pass through three or four generations that may or may not be well connected to each other over the course of so much time. Frequently there are barriers to intergenerational communication. There may be significant geographical separations. Interests may differ. Environmental and social milieus may contrast and often have varying impacts on different people. With the possible exception of family businesses and philanthropies, it is uncommon for families to be knit across generations in a substantive fashion. This is the story of one family that was able to maintain intergenerational bonds largely through common interests in science and photography and the sense of place provided by the Canadian Alps. It is a story told with photographic images augmented with a few words to provide context and detail. It is the story of three generations of the Vaux family, a family of individuals who were sometimes separated geographically and had varied interests but whose passion for science and the photographic arts created an unusual bond.

<div style="text-align: right">

— Henry Vaux Jr.
El Cerrito, California
December 2013

</div>

Acknowledgements

I owe an enormous debt to Craig Richards, curator of photography at the Whyte Museum of the Canadian Rockies, photographer extraordinaire and good friend. Craig has taught me much of what I know about photography. He has been a strong and unflagging supporter of this project, offering wisdom and technical advice at every point along the way. The project would not have been possible without his help and participation.

I am also indebted to all of the staff of the Whyte Museum for help and support, including former directors Ted Hart and Michale Lang for encouragement and counsel, and reference archivist Lena Goon, who helped me to sort through the original 2,000 photographs made by the first generation of Vauxes. I am also grateful to Don Bourdon, former head archivist at the Whyte, who probably knows more about the Vaux family's activities in the Alps than anyone else. He shared much of his knowledge with me.

Parks Canada, the steward of the landscapes shown herein, provided additional and tangible support. I particularly wish to thank two former superintendents at Glacier National Park, Pam Doyle and Karen Tierney, for their support and for providing me with transportation to Asulkan Pass, where I made several images that I could not have obtained otherwise. I also wish to thank retired warden Cal Sime at Banff National Park for providing transportation to an otherwise inaccessible area.

I thank John and Karla Gaffney, who provided a roof over my head for my annual forays to the Alps and who participated in several of the hikes associated with the photography. John, a retired foreman with the Canadian Pacific Railway, took me on a memorable trip on the railroad up the Field Grade and through the Spiral Tunnels. Both John and Karla educated me about the historical role and importance of the railway. I thank Ed Cavell, another Canadian friend, for taking time from a busy schedule to author the foreword to this volume.

I also wish to thank several individuals and institutions for providing recognition of some of the work that comprises this volume. The Alpine Club of Canada invited me to speak and share photographs on the occasion of their centennial celebration at Rogers Pass. The California Museum of Photography at the University of California, Riverside, exhibited a subset of my picture pairs under the title "Fire and Ice." Guy Clarkson included some of the family history and photography in his television production "The Shining Mountains." The Whyte

Museum of the Canadian Rockies presented some of the photographic work in this volume in two different exhibitions, "Art Born of Science" in 2003 and "Gateway to the Rockies," which opened in 2012.

Finally I wish to thank members of my immediate family, who provided constant support. It pleases me greatly that my father, Henry Sr., was able to participate in some of the early phases of the project prior to his death in 2000. My sister, Missy (Alice), has been a constant source of support and participated in some of the photographic efforts early on. My cousin Trina Vaux read and commented on portions of the manuscript and straightened me out on numerous factual matters related to the history of the Vaux family. My lifelong friend and companion, Charlotte Squier, accompanied me on many of the hikes that were part of the photographic effort. Among other things, she climbed Avalanche Crest and endured an unexpected encounter with a grizzly bear at Bow Lake. These were not events that had been advertised in advance but she accepted them with her usual aplomb. All of these people and institutions have materially improved the contents of this volume. None bears responsibility for any errors of fact or interpretation, however. That responsibility is solely mine.

— H.V. Jr.

Introduction

The Vaux family was originally English with French antecedents. Some members of the family immigrated to the United States in the 18th century to escape religious persecution in England. They came to Pennsylvania with other Quakers and ultimately settled in the Philadelphia area. One member of the earliest generation of American Vauxes was James Vaux, who was a highly successful farmer at Valley Forge. The story is told that on a cold night in the winter of the American Revolutionary War there was a knock on the door and the visitor, General George Washington, asked if he could come in and warm himself. He sat by the fire and dried his boots on the andirons while engaging in small talk with James Vaux. After some hours he departed to be with his troops. The next evening there was a knock on the door and it turned out to be the English general, William Howe. General Howe sat in the same chair by the fire and attempted to dry his boots. James Vaux told General Howe that General Washington had been there the night before. Howe replied, "I wish I had known that. I would have come over and caught him."

James Vaux was the second-born male in his family and consequently did not qualify for the long-standing family tradition of naming first-born male children "George." The grandson of James Vaux was the eighth in a long succession of George Vauxes. George VIII sired the first of the three generations of Vauxes who are the focus of this volume. His three children were Mary, George IX and William, born in 1860, 1863 and 1872 respectively. They are shown in Figure 1. George VIII's wife, Sarah Morris Vaux, died in 1880, leaving her husband and the three children. All three children were educated at Quaker schools in the Philadelphia area. George IX subsequently graduated from the University of Pennsylvania law school and had a long career as a corporate and estate lawyer in Philadelphia. He also served for 21 years on the U.S. Board of Indian Commissioners, which at that time provided oversight for the U.S. Bureau of Indian Affairs. Additionally, he engaged in numerous philanthropic activities. William trained as an engineer and worked as an engineer/architect in Philadelphia. His expertise proved crucial to some of the family's later scientific contributions. Mary spent her first 54 years at home managing the household and farm, where she proved to be a prize-winning Guernsey breeder. These three came, with their father, to the Selkirk Mountains of British Columbia in 1887.

The trip was the first of many visits to western Canada and the beginning of a prolonged period of fascination and focus on the landscapes of the Canadian Alps.* The uncle of these three, William Sansom Vaux, was a noted mineral collector and an enthusiastic and high-level functionary in the Philadelphia Academy of Natural Sciences. He provided much of the impetus for the interests of the entire family in natural and earth sciences. It was also the age of the amateur scientist, and this generation of Vauxes was enthusiastically involved with interests in minerals, botany and photography. The Vauxes pursued these scientific interests both at home in Philadelphia and during their many travels. George VIII had had a near drowning experience as a young man and was consequently afraid of ocean travel. Family travels were thus confined to North America.

*As used here, "Canadian Alps" is defined to include the Selkirk Mountains of eastern British Columbia and the Canadian Rocky Mountains of British Columbia and Alberta. Vaux activities were focused on those ranges, although some of their annual visits were part of more extensive trips throughout the U.S. and Canada.

THE FIRST GENERATION

In 1887 George VIII and his three children journeyed to the west coast of the U.S. and arrived in Vancouver, British Columbia, on the way home. They were great fans of rail travel and were eager to ride the newly completed Canadian Pacific Railway to Montreal. The journey brought them to the Glacier House hotel in Rogers Pass in the Selkirk Mountains. Here

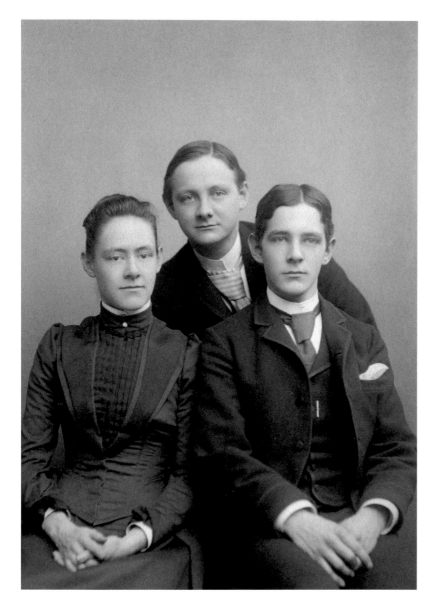

16

FIGURE 1: *(l to r) Mary, George IX and William Vaux*

they became captivated by the Great Glacier, known also as the Illecillewaet Glacier, and the surrounding Selkirk peaks. At that time, the tongue of the Illecillewaet was a 20-minute walk from the hotel, and the Vauxes took advantage to make photographs. William also made a fairly detailed map of the tongue of the glacier. The Vauxes did not come back to Glacier House until 1894 and on that occasion they were struck by the extent to which the Illecillewaet Glacier had receded. There then began their great adventure with photography, science and these mountains.

The photographic interests of the first generation began around 1880. By 1884 George and Mary were members of a group in Philadelphia that was dedicated to the advancement of photography as an art form. During the 1880s they made many photographs on their trips west. Presentations and exhibits of the photographs on the east coast were well received. Quakers of that era tended to eschew the arts as frivolous, but the Vauxes, as liberal Quakers, did not subscribe to such beliefs. Indeed the close interaction between their science and the photographs suggests at least the possibility that they masked their interest in photographic arts behind a veil of scientific inquiry. Following their initial excursions in 1887 and 1894, a member of the first generation was in the Canadian Alps every year from 1894 until 1908 (Figure 2). William died in 1908 at the age of 36 and George IX and Mary attempted to carry on the photography for a time. The press of George IX's law practice and public service activities became increasingly time-consuming and he did not return to the Canadian Alps after 1912. Mary continued to visit most years until her death in 1940.

Between 1887 and 1915 the first generation of Vauxes made approximately 2,000 photographs of the Canadian Alps and environs, as well as scenes from their more extensive travels in North America. All three members of the first generation participated in making and printing these photographs, and that is why the images are credited to the "Vaux family" rather than to one or another of the three siblings. These photographs, now held by the Whyte Museum of the Canadian Rockies in Banff, Alberta, constitute a unique and valuable record of the landscapes and human activity in the Canadian Rockies and the Selkirks of that era. A representative subset of the photo collection was included in a major exhibition at the Whyte in 1982. The catalogue from that show, *Legacy in Ice*, by Edward Cavell, should be considered the foundation for the present volume. In 2003 the Whyte Museum mounted an additional exhibition of representative photos, entitled *Art Born of Science: The Vaux Family amidst Mountains and Ice, 1887–2002.*

The present volume includes a group of those original photographs and pairs them with images made a century later from precisely the same locations as the originals. The original images and the associated rephotography provide a means of visually understanding changes that have occurred in the landscapes of the Canadian Alps over the intervening century.

The photographic and scientific endeavours of the first generation of Vauxes essentially came to an end with the death of William in 1908 and with George IX's intensifying focus on professional and philanthropic activities after 1912. Mary carried on for another 25 years with annual trips to the Rockies and as an active member of the Alpine Club of Canada. In

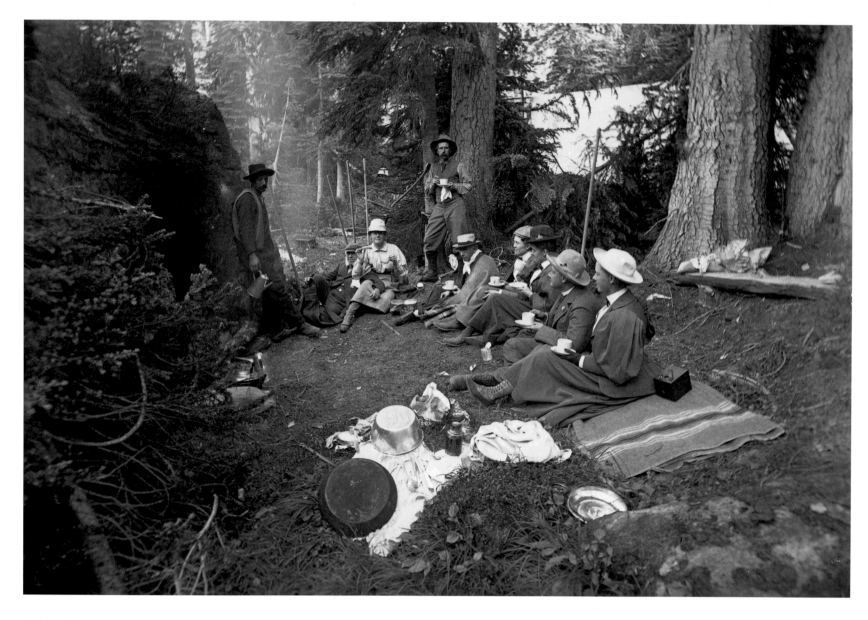

FIGURE 2: *The First Generation and Friends: Tea at Marion Lake, 1897*

1912 she encountered Charles Doolittle Walcott at his camp on Mount Burgess almost by accident. At the time, Walcott was the foremost paleontologist in the world and a distinguished public servant who at the time was secretary of the Smithsonian Institution. There followed lengthy conversations and correspondence focused heavily on Walcott's paleontological work and on the development and interpretation of the fossil record he had discovered at the Burgess Shale site. In 1914 Charles Walcott and Mary Vaux were married in Bryn Mawr, Pennsylvania.

Subsequent summers were spent in the Rockies as Walcott continued his fossil collecting and Mary provided support.

Mary also worked independently, focusing on sketching and photographing wildflowers. She had developed an impressive knowledge of the systematic botany of North America and was a skilled illustrator. She also spent considerable time in Washington, DC, doing work that would lead to the publication of a significant folio of North American wildflowers. The five-volume *North American Wildflowers* was published by the Smithsonian between 1925 and 1929, financed with subscriptions Mary had raised. Mary returned to the Rockies most summers following Walcott's death in 1927. Her visits to the Canadian Alps spanned a period of more than 50 years and ended with her death in 1940.

THE SECOND GENERATION

William Vaux never married and Mary had no children. The second generation of Vauxes, then, consisted of the two sons of George Vaux IX. The eldest, George X, was born in 1908 and Henry in 1912 (see Figures 3 and 4). These two were most extensively involved in the Canadian Alps during the 1930s. The Second World War truncated their activity there, as both were in active military service. After the war, careers and families tended to limit their presence in the Alps.

George X was trained as a physicist and had a career that included teaching and the pursuit of scientific interests. George was an active member of the Trail Riders of the Canadian Rockies in the 1930s and served as its president for an extended period. He was consistently in the Rockies and

Selkirks during that time. He had a keen interest in photography and pursued it almost without interruption throughout his adult life. Although much of George X's photography in the 1930s focused on the Canadian Rockies, it was very much his own original work and there was little that could be considered rephotography. Still, George was encouraged by an influential member of the Alpine Club of Canada, and former dominion surveyor, A.O. Wheeler, to do some rephotography, and George accomplished that on a limited basis. One of those efforts, at the former tongue of the Yoho Glacier, appears as Figure 22. This image shows that some 30 years after the original photo was taken in 1906, the snout of the glacier had receded significantly.

FIGURE 3: *George Vaux X*

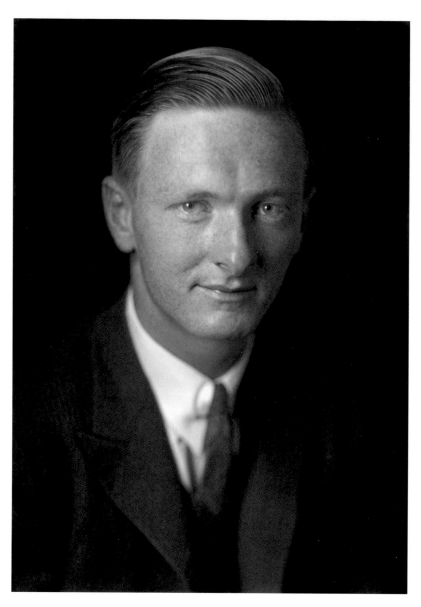

FIGURE 4: *Henry Vaux Sr.*

Henry, who was trained as a forester, served most of his career as professor of forestry and dean of the school of forestry at the University of California, Berkeley. His involvement with the Canadian Alps was somewhat more sporadic than his older brother's. He visited the Rockies a number of times in the late 1920s and the 1930s, but after that he returned only twice – in 1957 and again in 1984 – with members of his immediate family. Henry too had a lifelong interest in photography but he pursued it in a more casual fashion. Much of his picture-taking was done during family and professional travel, to document places and events of family interest as well as forest practices around the world. Quite serendipitously, several of the images from his Rockies trip in 1957 document the extent of glacial recession at mid-century. These photos, of the Biddle and Bow glaciers, illustrate that glacial recession was occurring relatively constantly throughout the century.

THE THIRD GENERATION

The third generation consists of four persons, two of whom were fathered by George X and two by Henry Sr. I am the oldest of the four, and my sister, Missy, and I are offspring of Henry Sr. (Figure 4). George X's daughters, Trina and Molly, are the other members of the third generation. The life spans of the first generation do not overlap with those of the third.** Nevertheless, the third generation is well aware of the contributions of the first generation and were all present at the opening of the 2003 exhibition at the Whyte Museum in Banff along with members of the fourth generation. The third generation's interests in photography are considerably less intensive than those of the first two. Certainly, all have done some photography in the casual way of many people. I was given a camera at an early age and took pictures extensively until my college years. My interest resumed about a decade later but I pursued it only intermittently until relatively late in my career. The present project had its origins in a dinner table conversation with my father, Henry Sr., in which there was considerable speculation about what the ancestral photographs might look like if they were made today.

I began to pursue this project in 1997. Early efforts involved selecting photographs to be reproduced and going into the field to attempt to reproduce them, as well as participating in photographic workshops and working with mentors to develop and hone my skills in black and white photography. At first some 80 of the original photos were selected for inclusion in the project. That number was eventually reduced to 37, for several reasons:

1. A number of potentially interesting early photos were made on or close to the right-of-way of the new Canadian Pacific Railway. The mode of construction of the railway

** *Strictly speaking, though, my lifespan, which began in February 1940, does overlap briefly with that of Mary, who died in August of that year.*

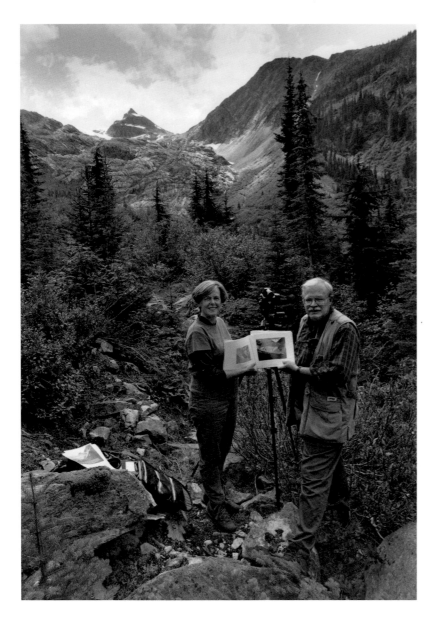

FIGURE 5: *Henry Jr. and Missy Vaux at Photographers' Rock, 2002*

entailed clear-cutting the roadbed alignment and some width on either side of it. This practice opened a number of spectacular views for the photographer. Today much of that clear-cut has grown back in and the original views are blocked.

2. Some views are no longer of interest visually or are spoiled by changes that have occurred over the past century. Thus, for example, a beautiful view of the Hermit Range in Rogers Pass is now compromised by the presence of a large truck-marshalling yard in the foreground.

3. With one exception, views that involved glacier traverses had to be eliminated because I lack the necessary skill and experience in glacier travel and ice climbing. The exceptions are the photos of the glaciers in the Dawson Range, which were made possible through the generosity of Parks Canada in providing transport to Asulkan Pass. The first generation had climbed to Asulkan Pass with a Swiss guide.

4. There were one or two instances where the need to ford streams barred access to the original photo sites.

5. There were several instances where the growth of vegetation and the abandonment of trails made it impossible to reproduce a photograph.

The present-day photographs chosen for this book were made during annual summer visits to the Canadian Alps between 1997 and 2013. After several years of effort it became apparent that the original photographs had been made at locations that were never far removed from trails or the railway. This close proximity made it relatively straightforward to locate the precise sites of the originals. However, most of the modern images do not appear as exact duplicates of the originals. There

are several reasons. First, it was not always possible to duplicate the exact weather and therefore the exact lighting. Second, all of the modern images were made with a medium-format Mamiya 645 camera using a variety of lenses and filters. The originals were made with a large-format field camera using a Bausch & Lomb lens which apparently could be reversed to increase or decrease the focal length. Thus, optical differences in the lenses produced images of slightly different dimensions and it would have been both difficult and time-consuming to correct for this.

This volume is divided into five sections, focusing respectively on glaciers, mountains, waterfalls, lakes and people. The 37 sets of comparative images (32 pairs and 5 triplets) are intended to illustrate how much things have changed even while they have stayed the same. The role of glaciers in the physical schemes of these mountains, particularly the hydrologic schemes, is an underlying theme. The final section, on people, is intended to show how the human endeavours in these mountains have remained very much the same throughout the intervening century.

In his foreword Edward Cavell quotes George Vaux IX, who observed that "… so little exploration had been carried out that each visitor is practically a new discoverer…". In the pages that follow, the landscapes of the Canadian Alps are shown as they looked to the first generation of Vaux visitors and again to the third generation 100 years later. I hope that 100 years of hindsight will provide the reader with the same sense of being "a new discoverer" that my grandfather described so long ago.

GLACIERS

Between 1887 and 2013, the period considered in this volume, glaciers were the single natural feature of the landscape that changed the most, visually. Glacial recession is apparent in many places around the world and is frequently cited as evidence of climate change. The Canadian Alps are no exception. The Illecillewaet Glacier was, when encountered by the first generation of Vauxes, a 20-minute walk from Glacier House. Today it is a four-hour technical climb. The changes are well illustrated in the first sets of comparative images of the Illecillewaet. The two initial visits, in 1887 and 1894, alerted the first generation to the fact that change was afoot in at least one glacier. William, by virtue of his engineering background, was able to set up a rigorous system for measuring the recession of the Illecillewaet Glacier. The system included observations made with a prismatic compass near the toe of the glacier and a series of plates installed on the glacier itself that allowed estimates to be made of the rates of its movement. These latter measurements were crucial for accurate assessment of the recession of the toe.

On each visit, William and George IX took numerous photographs, including an annual "test photo" which was made from a place along the Sir Donald/Perley Rock Trail that is today known as "Photographers' Rock." The test photos provided visual evidence that tended to confirm the measurements they made. Inasmuch as measurements were not made every year in the 1890s, the initial results (per annum) were reported as averages of the aggregate changes measured and inferred over the period from 1890 to 1898. These measurements showed that during that period the Illecillewaet Glacier receded 56 feet per year. During the period from 1898 to 1906 the average rate of recession was 33 feet per year. In 1907 the glacier receded 55 feet from its position the preceding year.

The amount of recession fluctuated significantly from year to year depending on snowfall, temperature and other variables. Yet the averages over multi-year periods were relatively stable, even when the extent of interannual variability was relatively large. Thus, for example, in 1899, recession was only 16 feet, but in 1900 it was 64 feet. Similarly, rates of recession in 1904 and 1905 were less than 10 feet but were followed in 1906 by the largest annual loss measured, 84 feet. Another significant finding related to the issue of just when the Illecillewaet Glacier began to recede. Mature alders found at the toe in 1887

suggested that the extent of the glacier had not been greater for some time than it was in 1887. William became aware of research at Johns Hopkins University leading to a new technique involving the counting of rings in woody plants to determine their age. The technique is today subsumed within the sub-discipline of dendrochronology. Using this technique to date the alder bushes, William determined that the toe of the glacier had not extended beyond the 1887 line for at least 30 years. All of these findings were documented and discussed scientifically in publications of the Philadelphia Academy of Natural Sciences and the Engineers Club of Philadelphia (See, for example, the various Vaux scientific papers cited in References.)

It is important to note that recession of glacial toes is not by itself evidence of glacier wasting. Rather, the decline or shrinking of glaciers is appropriately measured with reference to the entire volume of the glacier. Scientifically, a glacier can only be said to be declining if there is net wastage. That is, the wasting or decline of the glacier exceeds accretion over an extended period of time. At the time of the Vaux work, techniques to measure volumetric changes in glaciers were unavailable. However, as documented in the pages that follow, the persistent retreat of glacial toes over extended periods certainly suggests the existence of net wastage. The photograph pairs also reveal visually that significant changes in volume have been associated with the retreat of the glaciers in the last century.

Work was not confined to the Illecillewaet. Measurements were also made of the Asulkan, Wenkchemna, Yoho and Victoria glaciers. Comparative images of the Yoho and Victoria glaciers are shown in the pages that follow. In this connection, it is important to acknowledge that A.O. Wheeler, who worked as a dominion surveyor in the Selkirks and was an influential member of the Canadian Alpine Club, assisted and ultimately took over the measuring activity at Yoho and elsewhere toward the end of the first decade of the twentieth century. The observations at other glaciers were extremely important because they revealed that glacier recession was apparently a generalized phenomenon.

The work of this first generation of Vauxes, then, transcended their impressive photography. They were among the first to document scientifically the fact that glaciers on the North American continent were shrinking. Their early work predates by almost eight decades modern concerns and modern scientific evidence of the global warming cycle and the apparently significant acceleration of it caused by the human species. The scientific evidence which these Vauxes gathered and interpreted is solid and incontrovertible. It serves as a partial reminder that the world is subject to warming and cooling cycles which apparently occur independently of human activities. When combined with modern-day evidence, it supports a picture that suggests that the current warming trends are, at their core, natural trends but that these trends are being intensified and accelerated by human activity, including, most importantly, the continuing large-scale discharge of carbon into the atmosphere.

The following pages, focused on glaciers, provide examples of the beauty and elegance of the photography of the first Vaux generation. They also provide evidence – after the fact – of the veracity of their scientific findings.

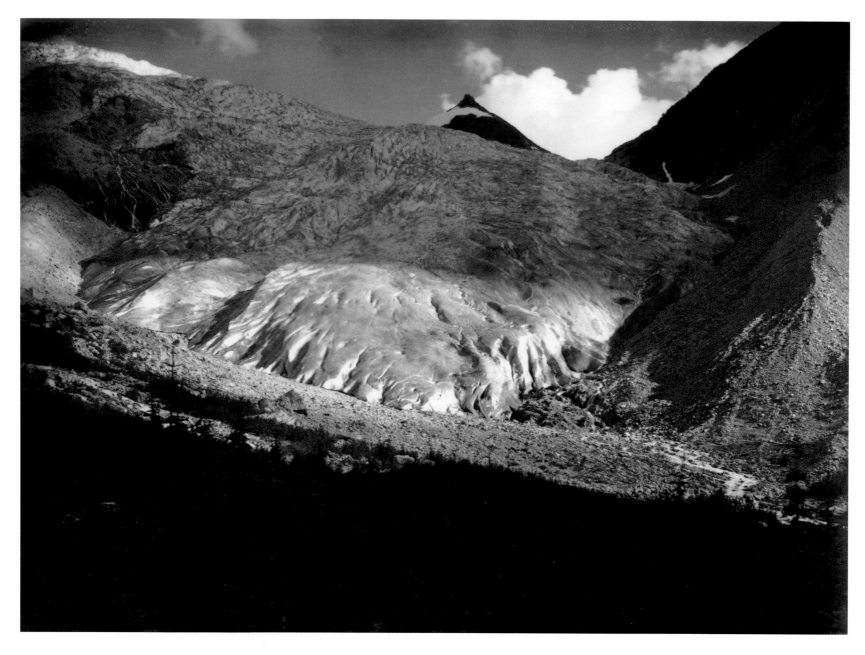

FIGURE 6: *Illecillewaet Glacier from Photographers' Rock, 1902*

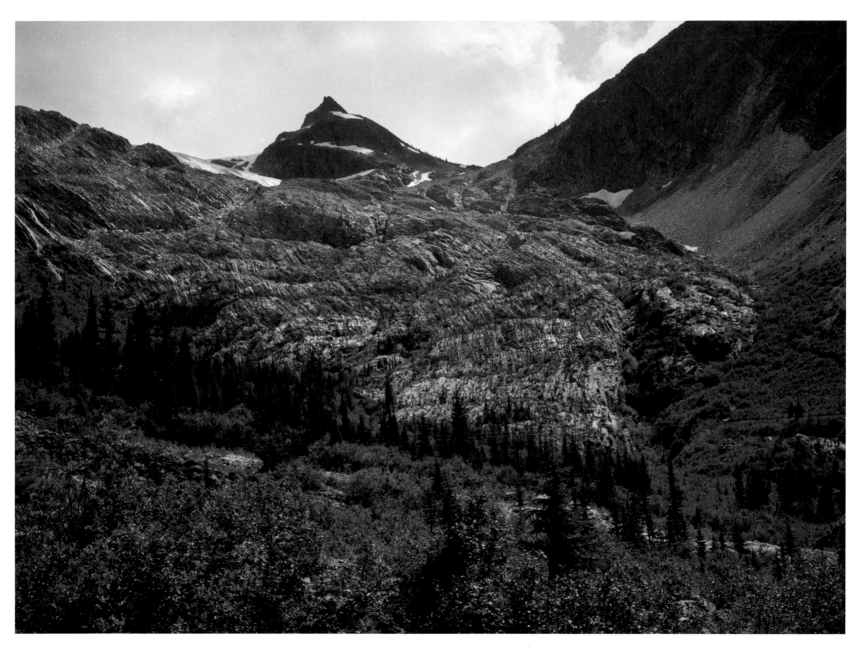

FIGURE 7: *Illecillewaet Glacier from Photographers' Rock, 2002*

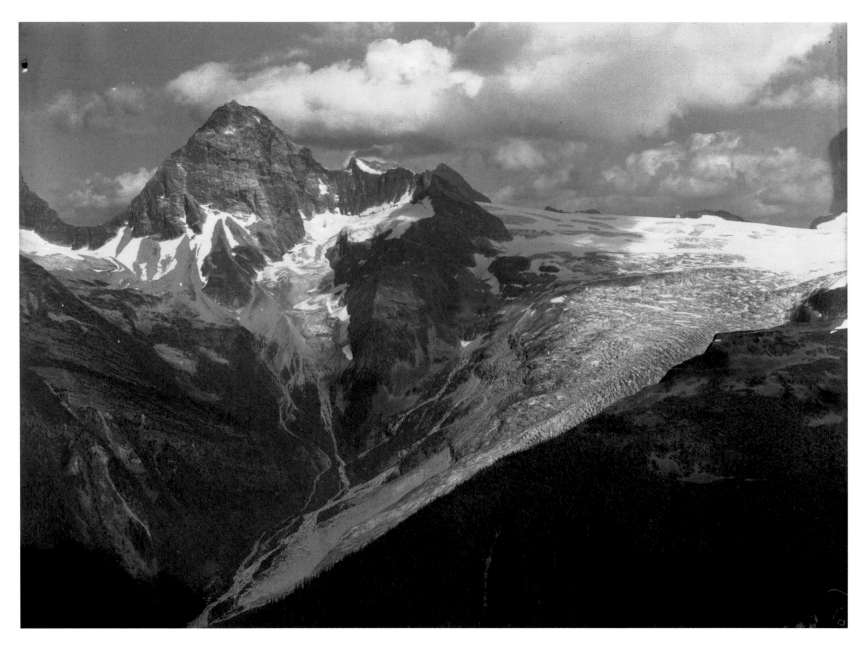

FIGURE 8: *Illecillewaet Glacier from Abbott Ridge, 1904*

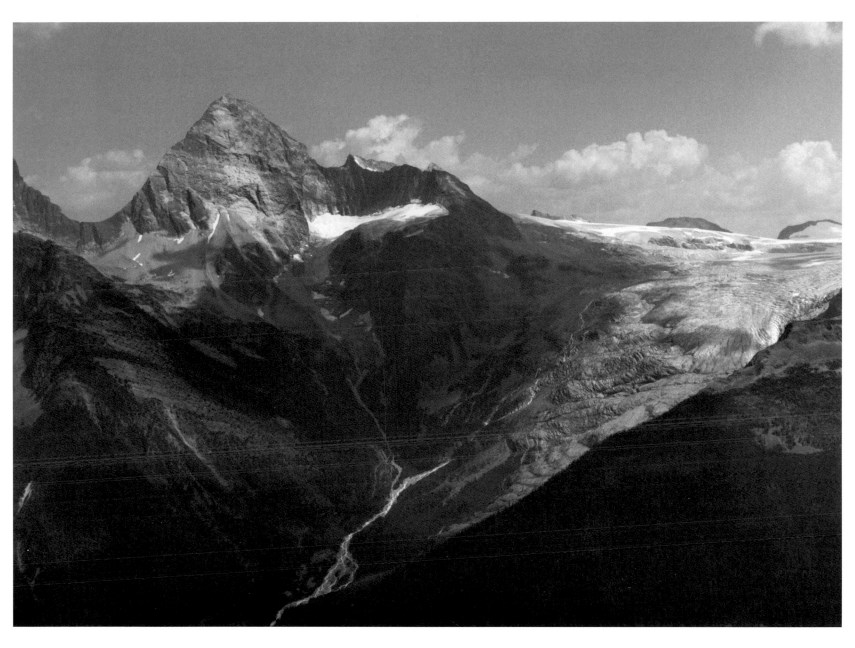

FIGURE 9: *Illecillewaet Glacier from Abbott Ridge, 2004*

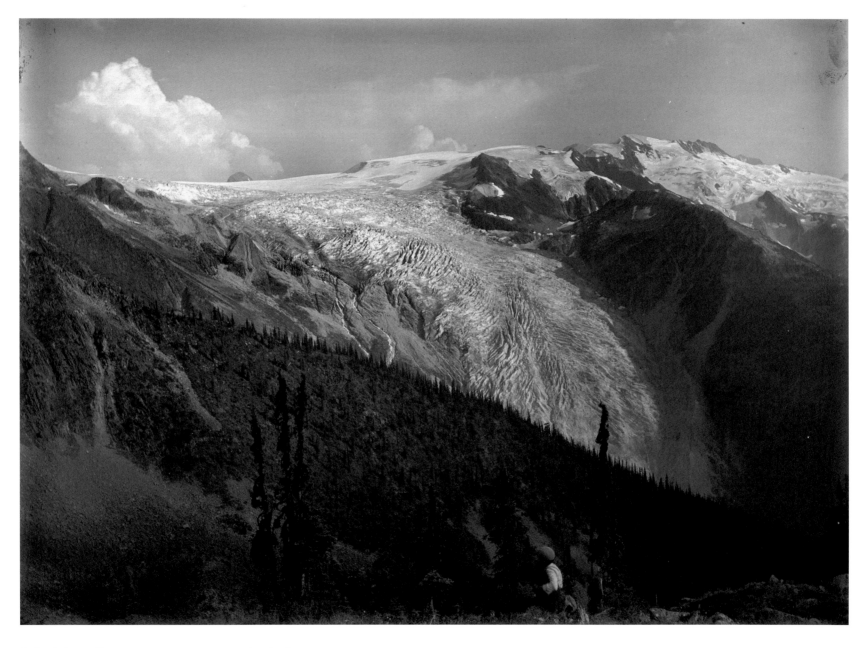

FIGURE 10: *Illecillewaet Glacier from Avalanche Crest, 1898*

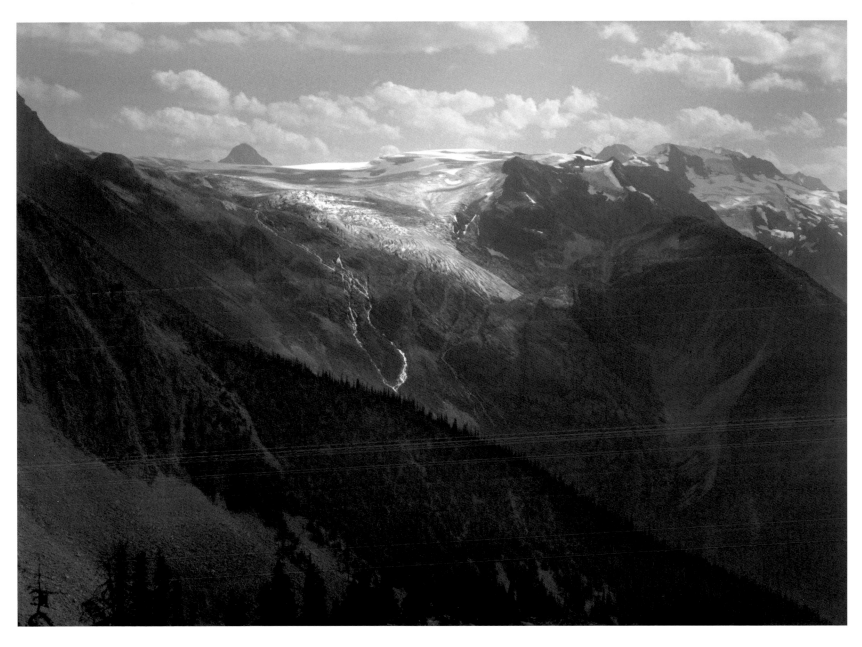

33

FIGURE 11: *Illecillewaet Glacier from Avalanche Crest, 2007*

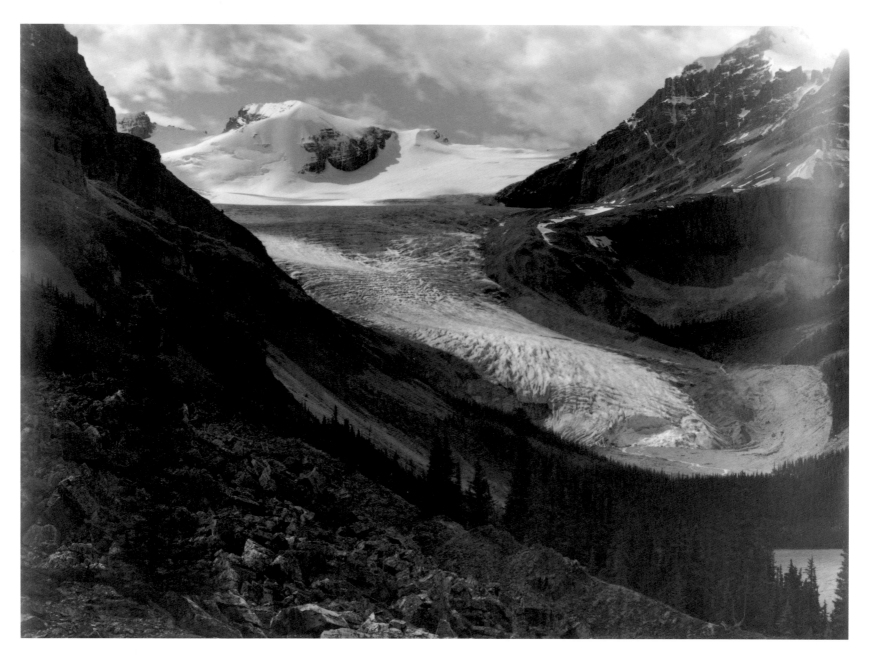

34

FIGURE 12: *Peyto Glacier, 1902*

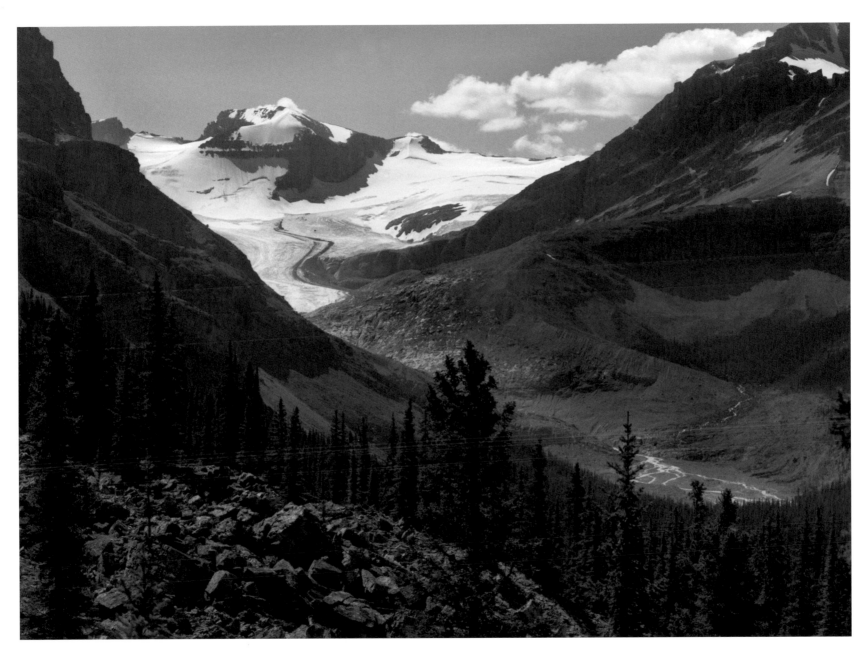

FIGURE 13: *Peyto Glacier, 2002*

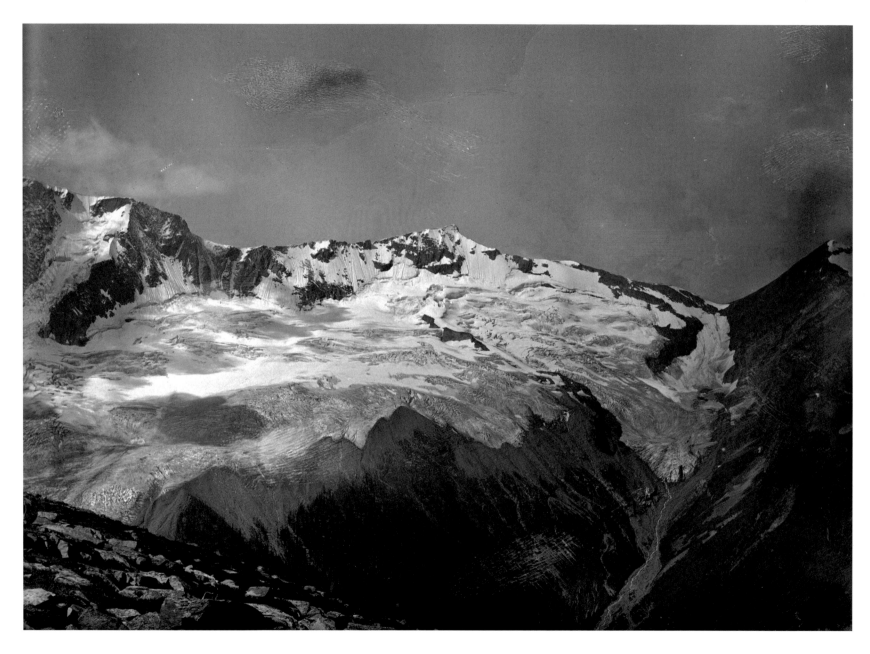

FIGURE 14: *Bonney Glacier, 1897*

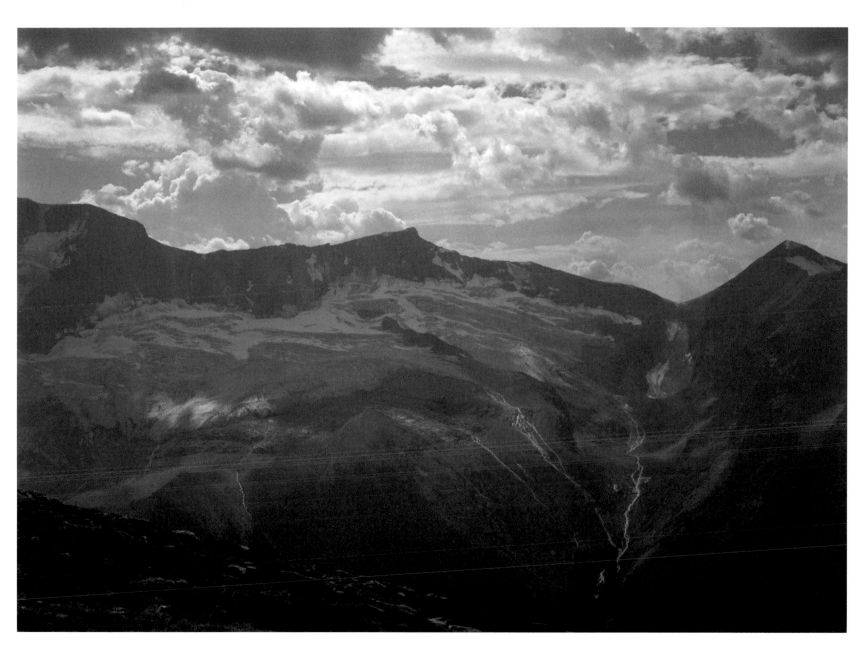

FIGURE 15: *Bonney Glacier, 2004*

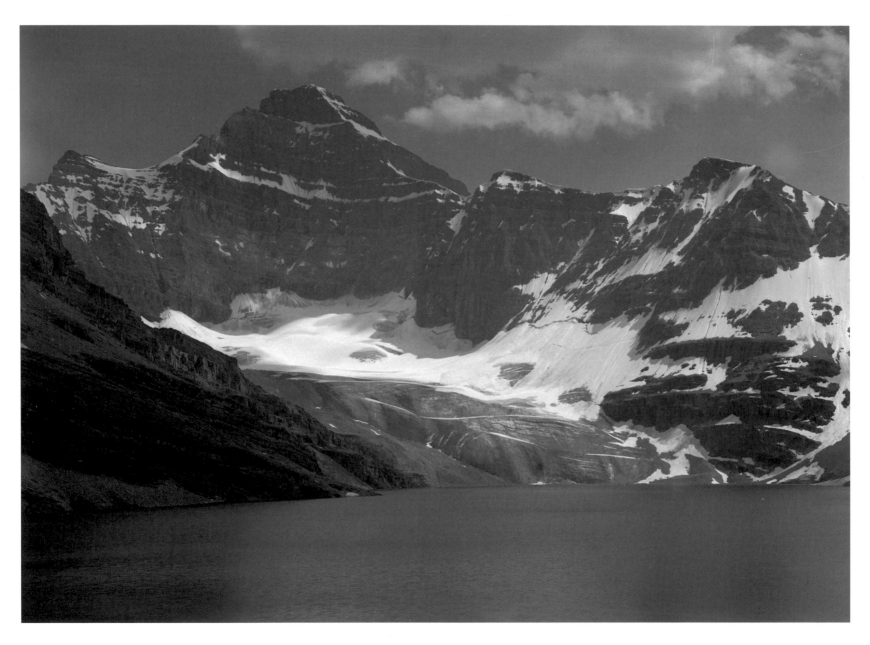

38

FIGURE 16: *Biddle Glacier, 1902*

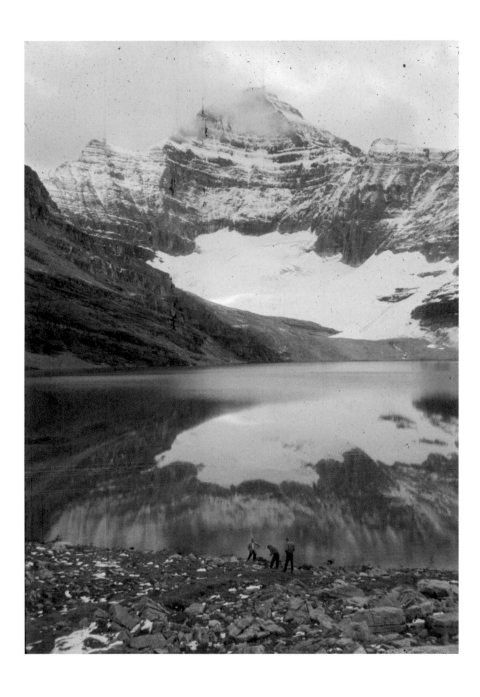

FIGURE 17:

Biddle Glacier, 1957

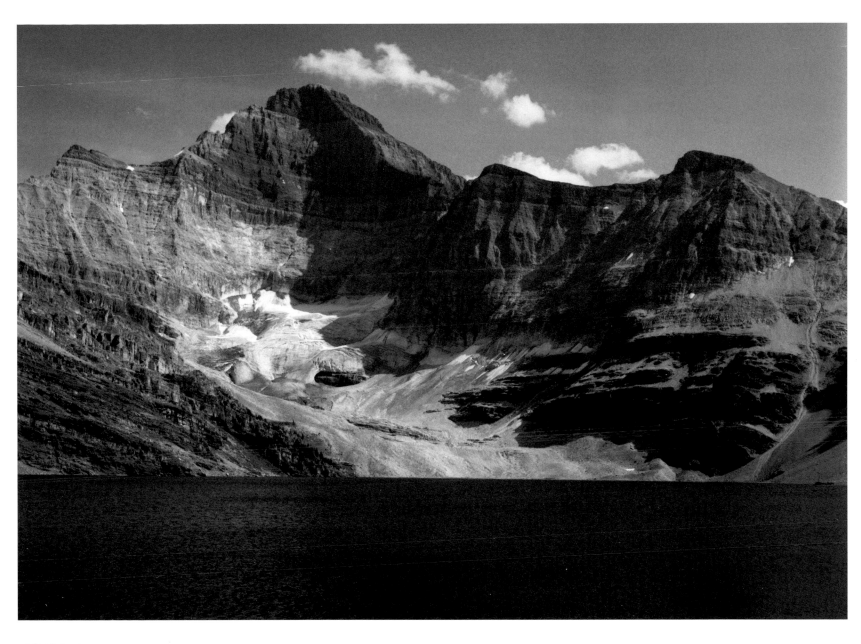

FIGURE 18: *Biddle Glacier, 2006*

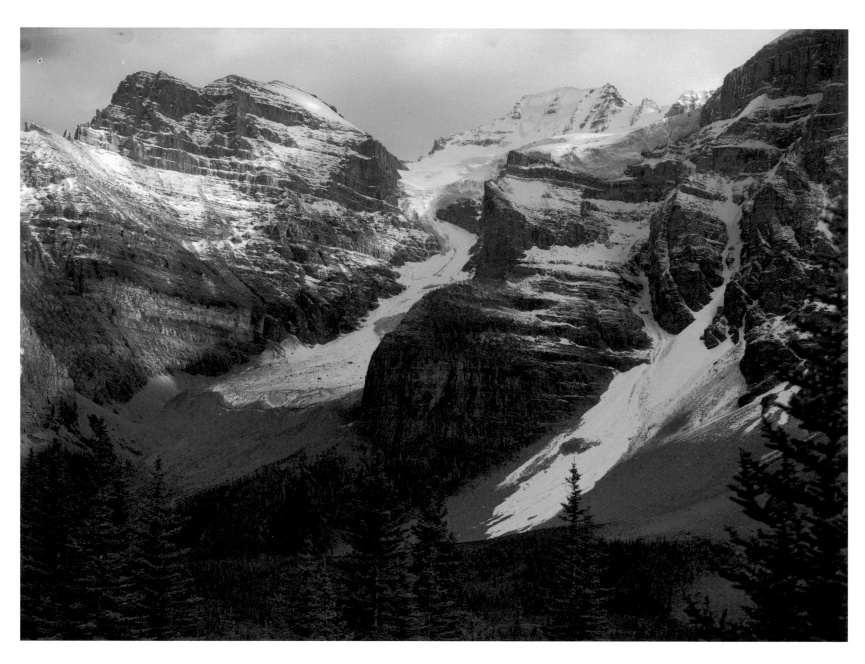

42

FIGURE 19: *Fay Glacier, 1902*

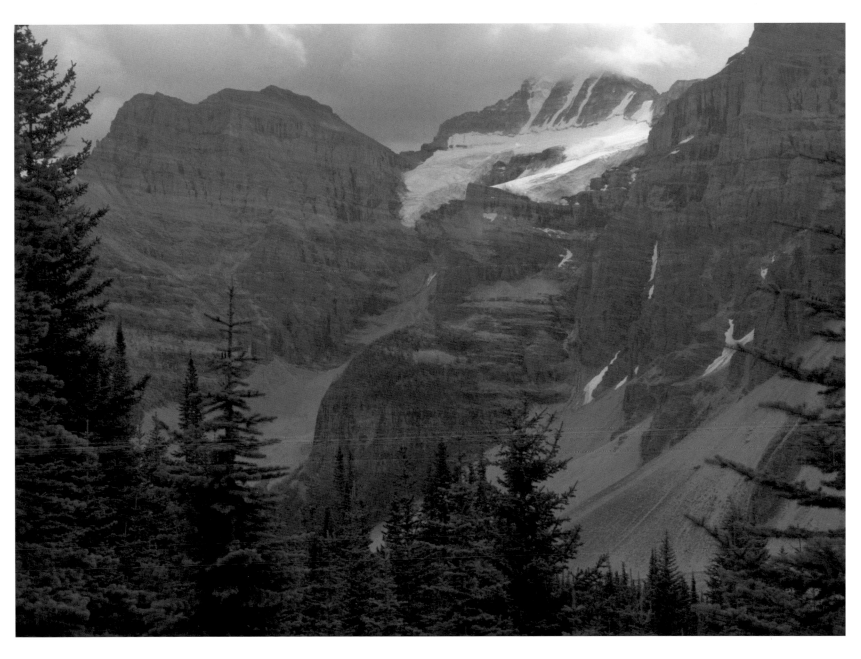

FIGURE 20: *Fay Glacier, 2009*

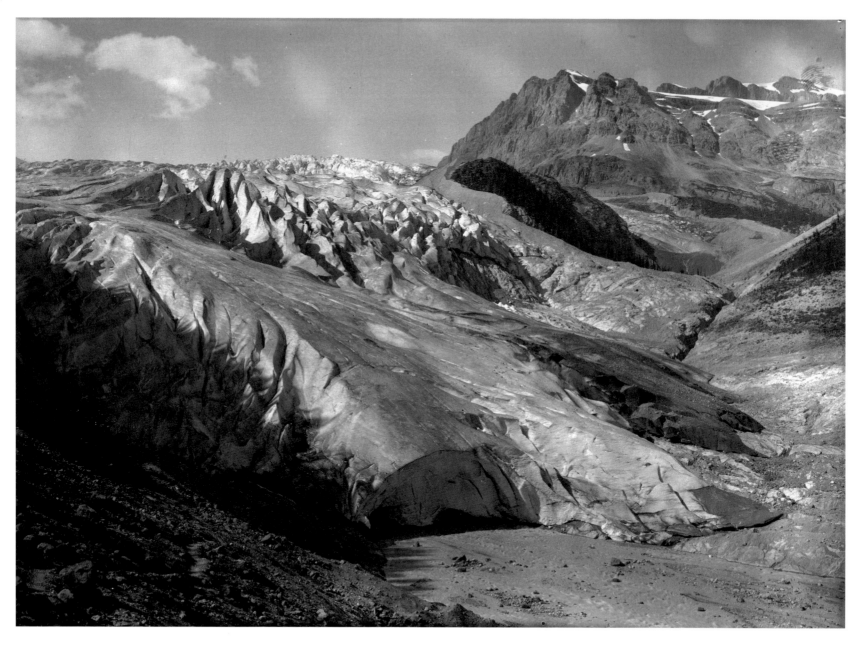

44

FIGURE 21: *Yoho Glacier, 1906*

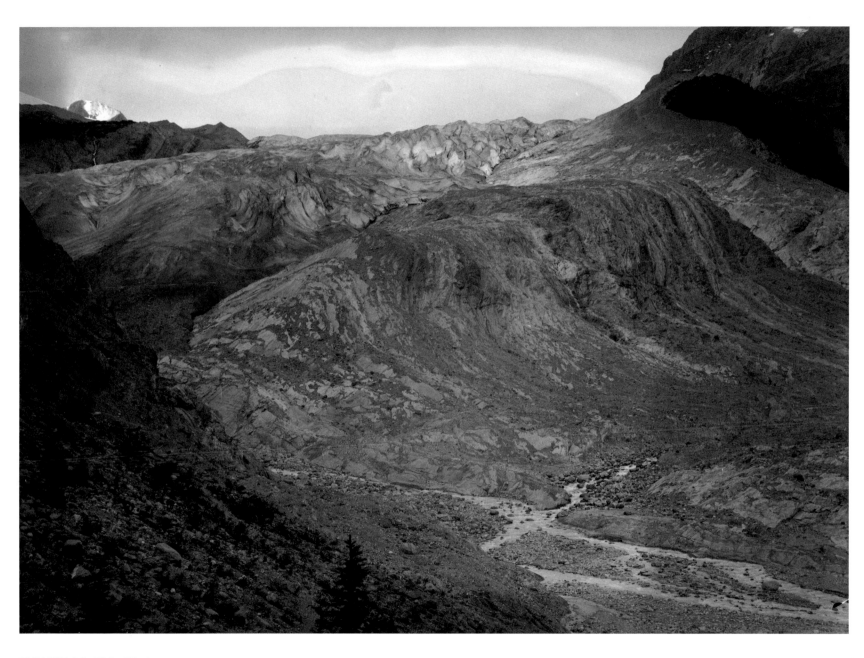

FIGURE 22: *Yoho Glacier, 1930*

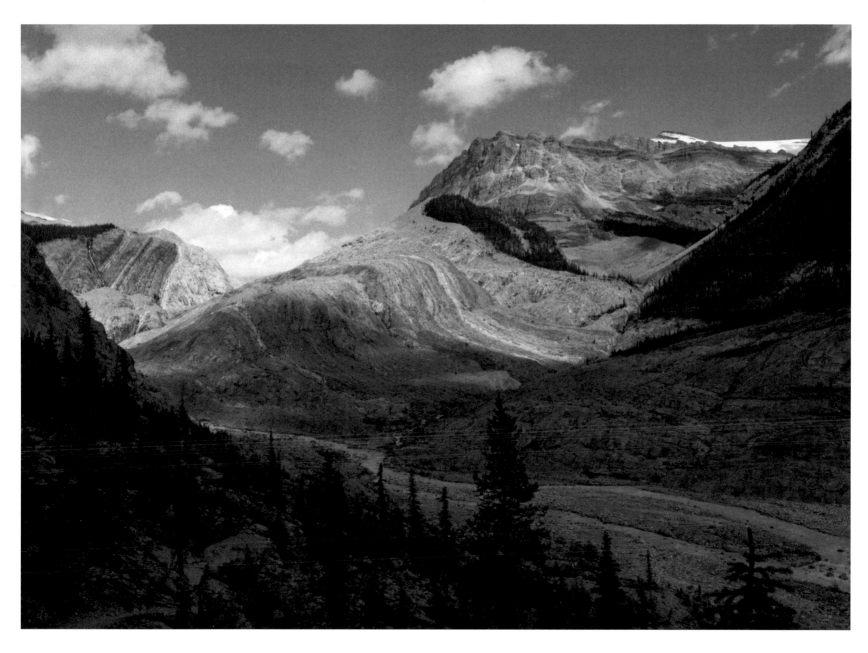

FIGURE 23: *Yoho Glacier, 2006*

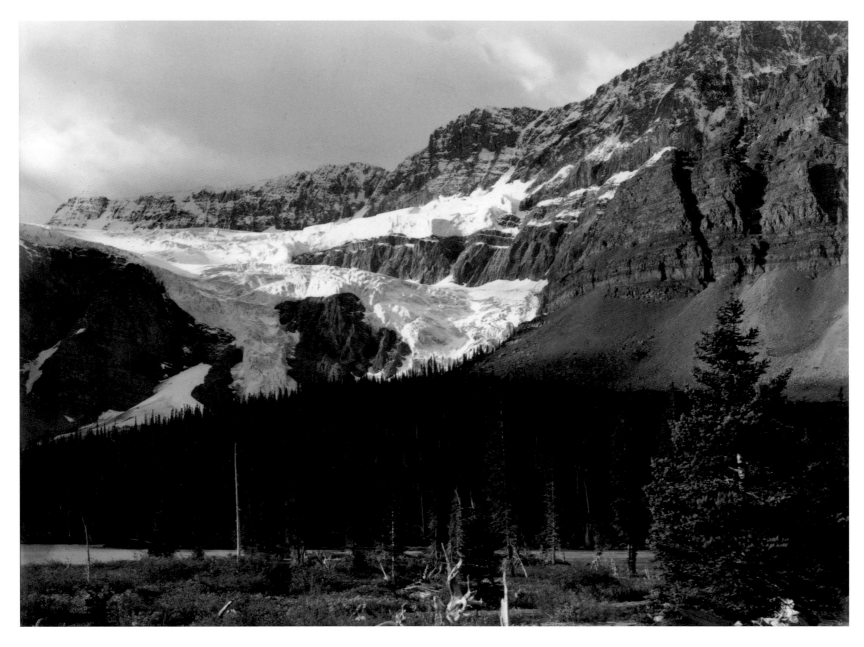

FIGURE 24: *Crowfoot Glacier, 1902*

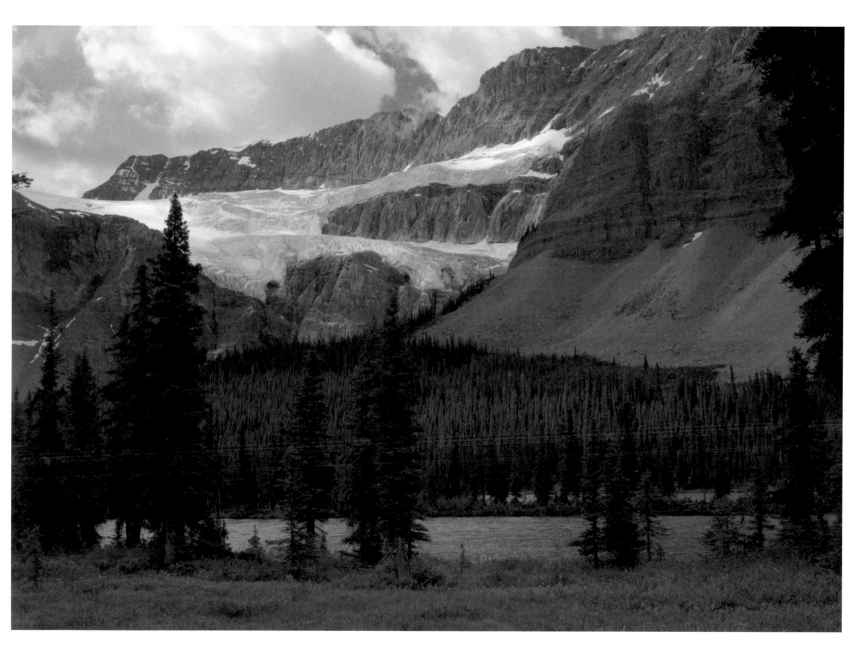

FIGURE 25: *Crowfoot Glacier, 2002*

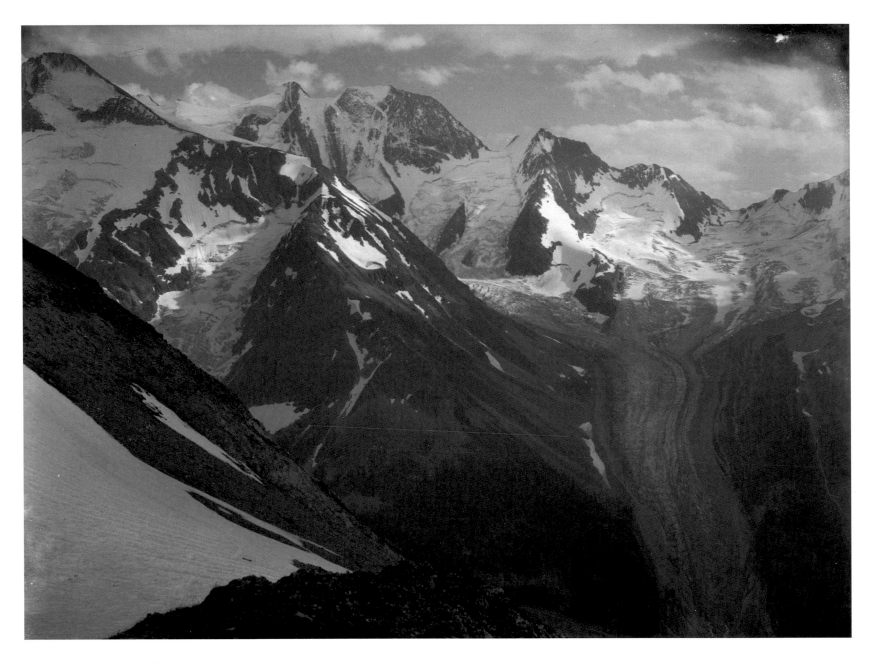

FIGURE 26: *Dawson Glacier, 1904*

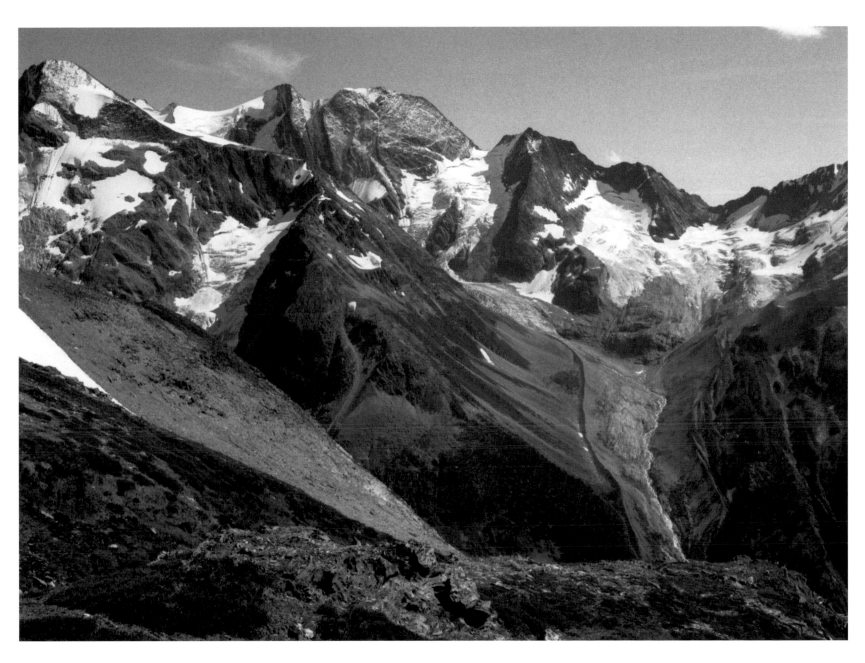

FIGURE 27: *Dawson Glacier, 2007*

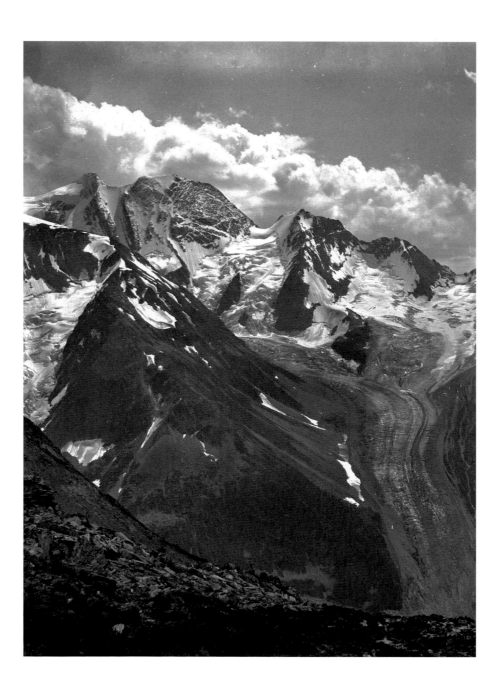

FIGURE 28:

Dawson Glacier, 1897

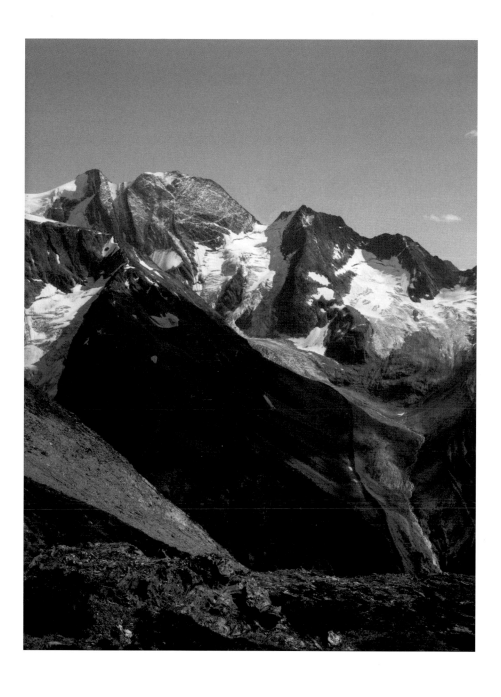

FIGURE 29:
Dawson Glacier, 2007

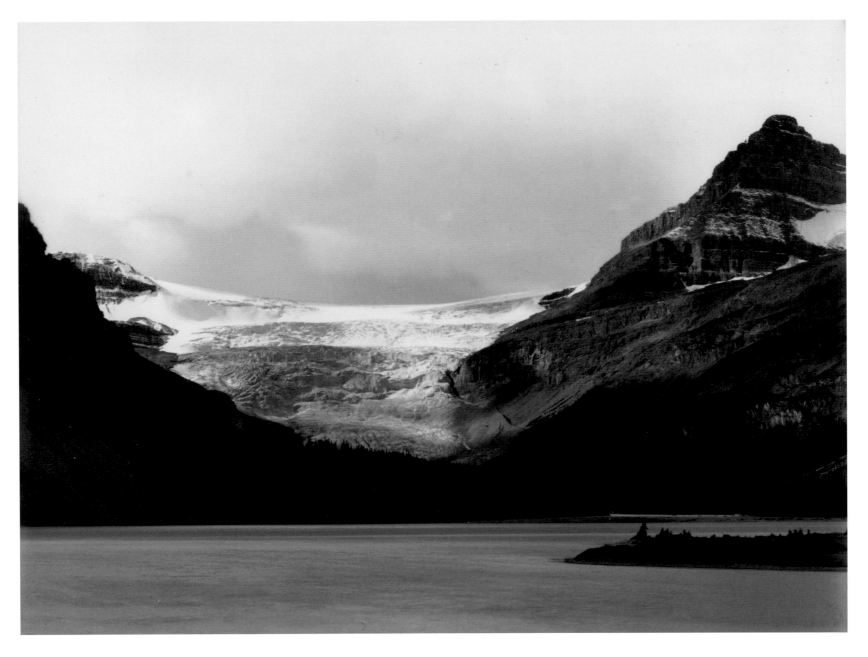

54

FIGURE 30: *Bow Glacier, 1902*

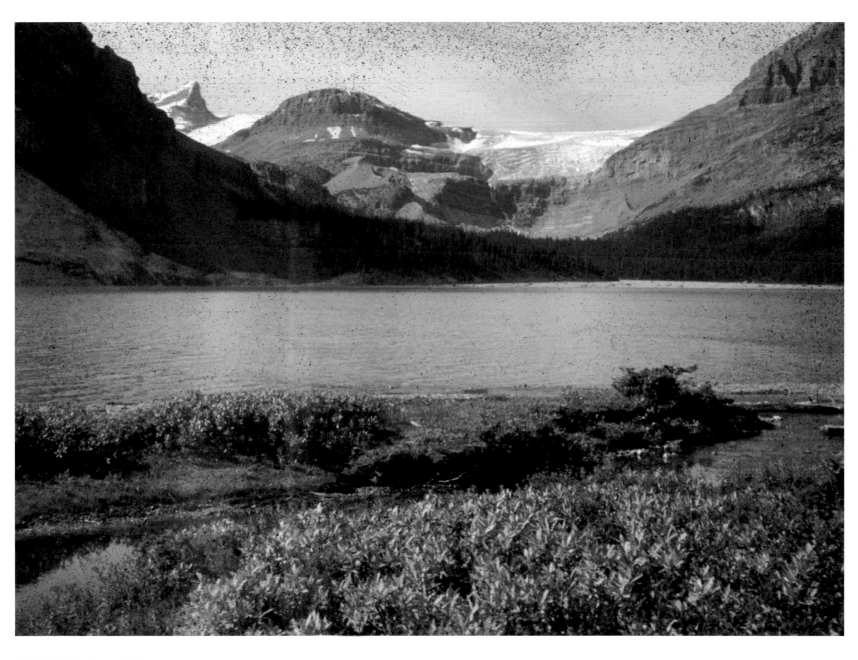

FIGURE 31: *Bow Glacier, 1957*

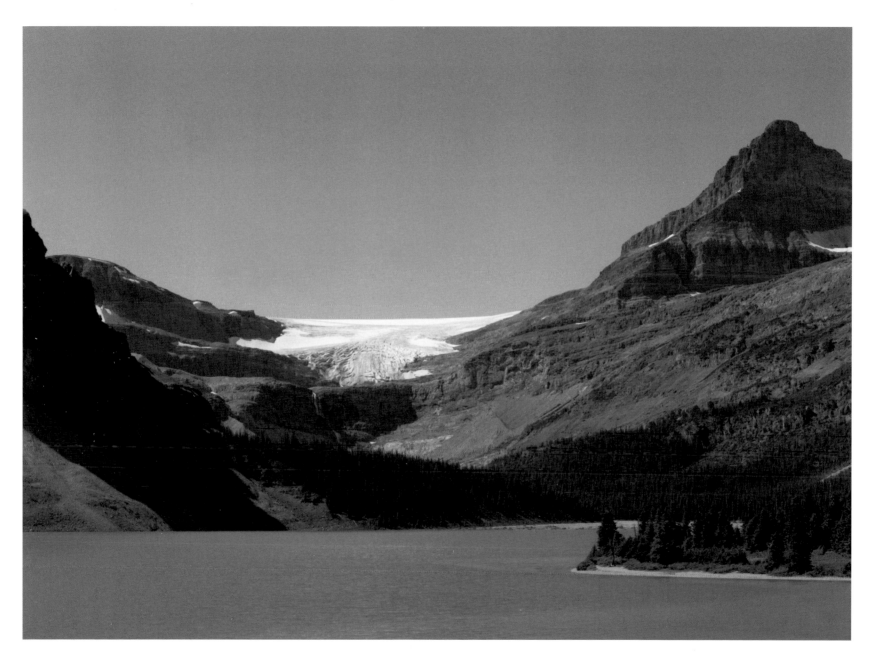

FIGURE 32: *Bow Glacier, 2002*

MOUNTAINS

Glaciers and mountains are inextricably linked. Mountains are the domains and birthing grounds of glaciers, and glaciers cannot be understood without knowing something about mountains. Several of the mountain pairs shown in this section still have active glaciers and provide evidence of glacier recession. Thus, for example, the upper portion of the Assiniboine Glacier at Mount Assiniboine appears to be about the same thickness that it was a century ago. But the lower part of it has virtually disappeared. The glaciers at Wonder Peak and Mount Lefroy have visibly receded. Although Mount Stephen and Cathedral Mountain appear to be unglaciated, significant glaciers are present on the faces opposite those photographed. By contrast, the last two pairs, the Tower of Babel (the first summit in the Valley of the Ten Peaks) and Mount Burgess have been unglaciated for the past century. There has been very little, if any, change in their appearance over the intervening century.

The photo pair of Cathedral Mountain, Figures 41 and 42, bear special attention. While the recession of the glaciers may be the most visually apparent change in the landscapes of the Alps, the other dramatic alteration has been caused by man. The early photo, made in 1903, shows the right-of-way of the Canadian Pacific Railway across the debris flow at the middle right-hand edge of the frame. There is also evidence of a past wildfire that may or may not have been started by human activity associated with the railway. By contrast, the modern image, made in 2003, shows – from the top – a reinforced concrete debris shed across the debris flow, a highway bridge across the Kicking Horse River that carries the Trans-Canada Highway and, in the foreground, a levee built to provide protection from flooding of the Kicking Horse River. This simply serves to draw attention to the fact that many of the most visually obvious changes in the Alps have their origin in the works of humans.

As for the mountains themselves, they appear largely unchanged. The glacial and hydrologic processes that wear them down tend to act over very long periods. In the context of these processes, the images show that a century is a very short interval. Over time the mountains anchor the landscape. The mountains abide.

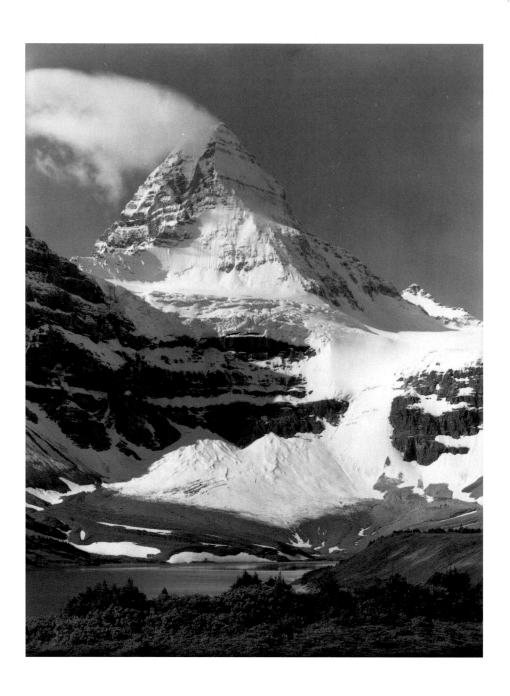

FIGURE 33:

Mt. Assiniboine, 1907

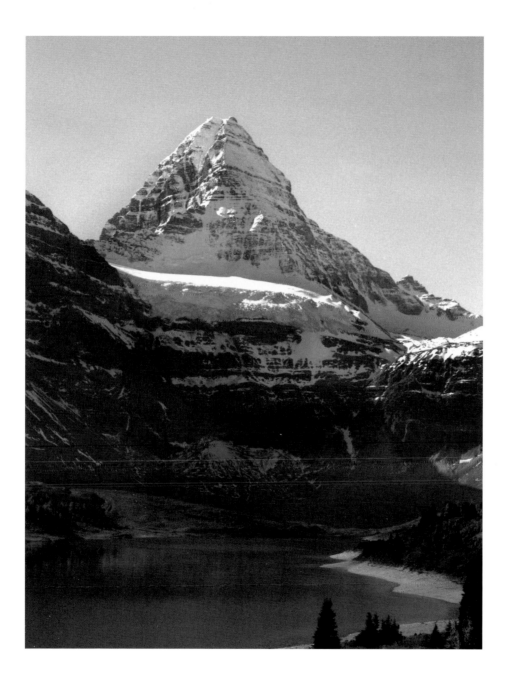

FIGURE 34:
Mt. Assiniboine, 2006

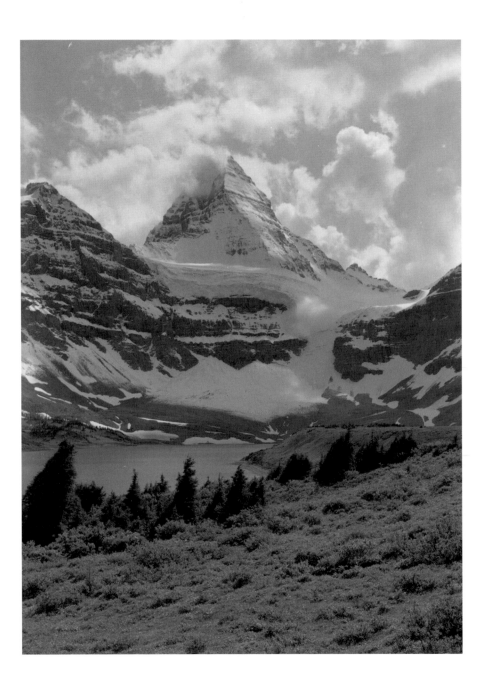

FIGURE 35:

Mt. Assiniboine, 1907

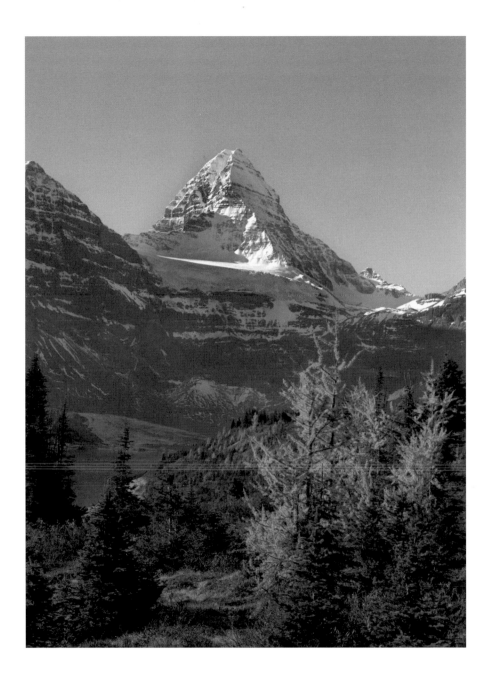

FIGURE 36:

Mt. Assiniboine, 2006

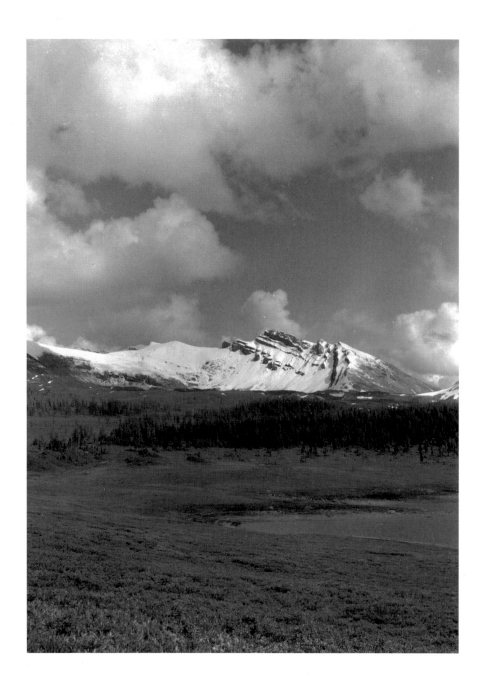

FIGURE 37:

Wonder Peak, 1907

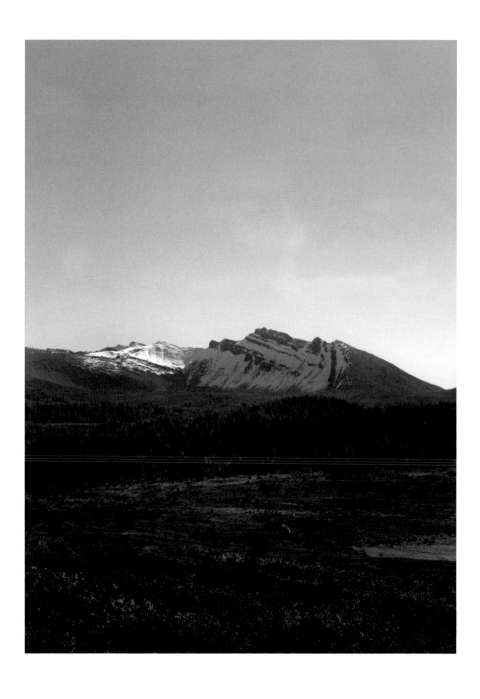

FIGURE 38:
Wonder Peak, 2006

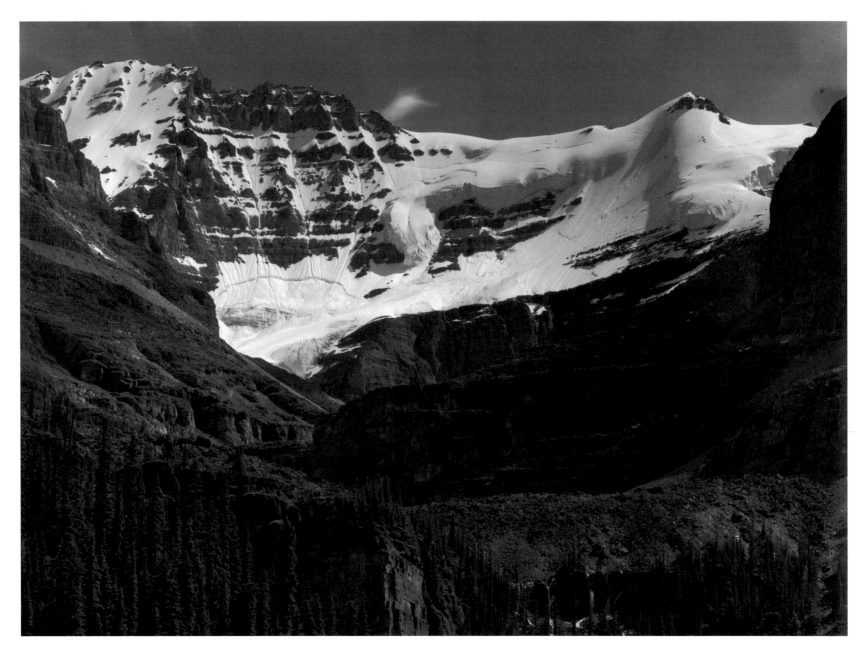

66

FIGURE 39: *Mt. Lefroy, 1902*

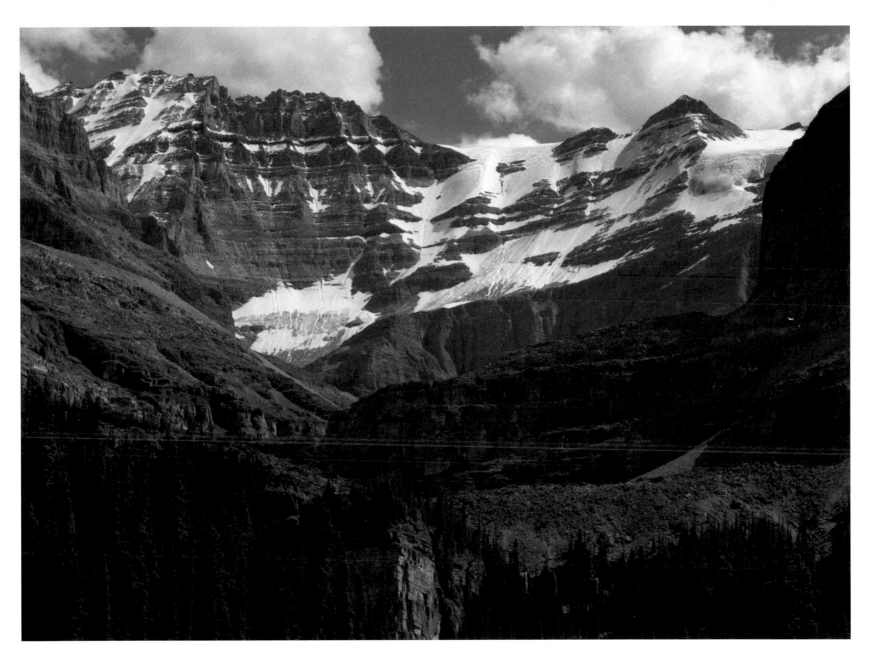

FIGURE 40: *Mt. Lefroy, 2002*

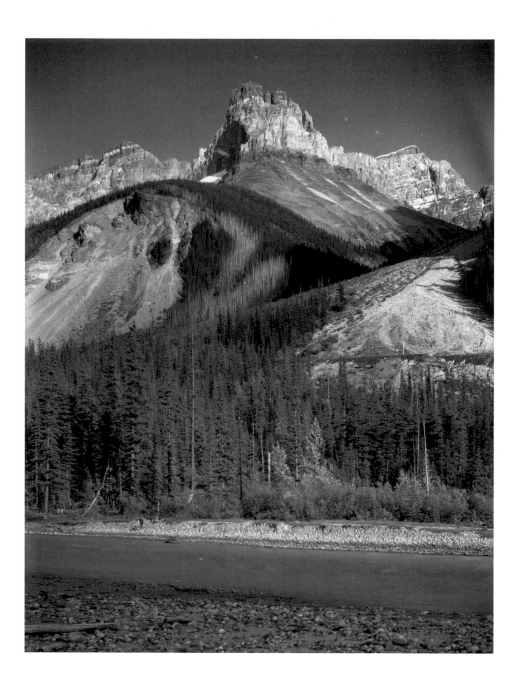

Cathedral Mountain, 1903

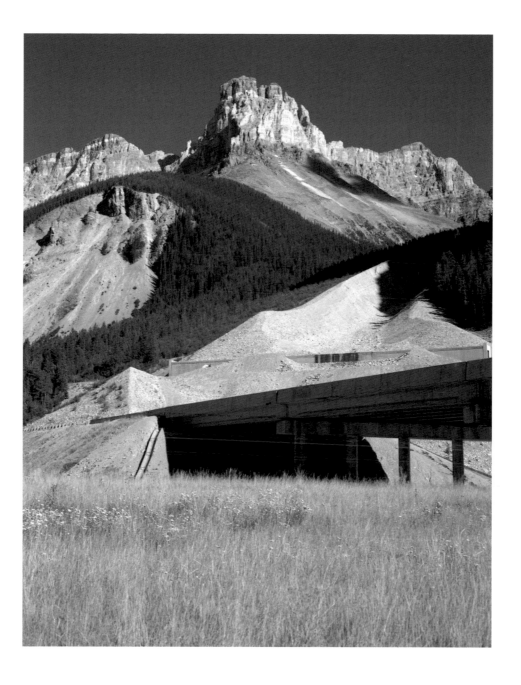

FIGURE 42:
Cathedral Mountain, 2003

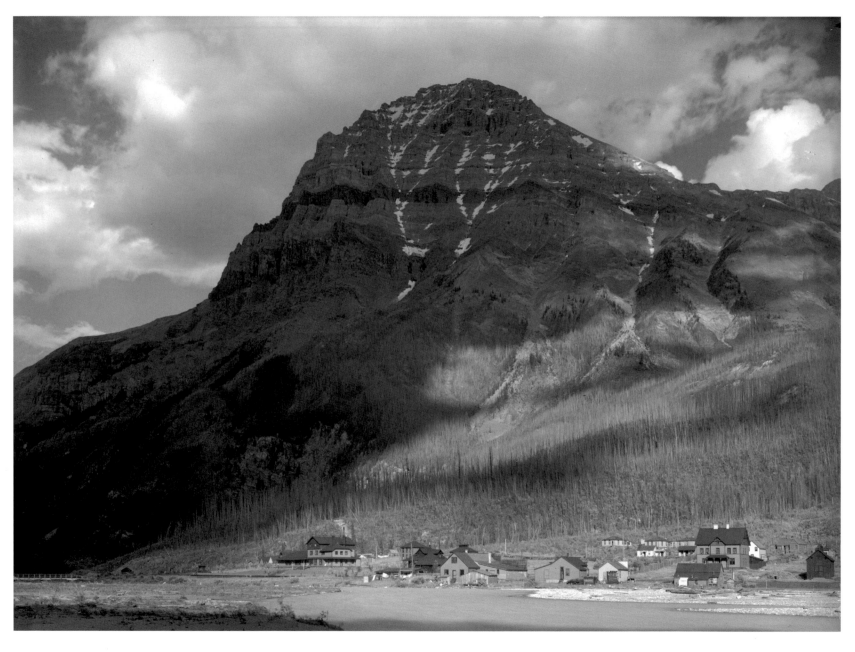

FIGURE 43: *Mt. Stephen, 1902*

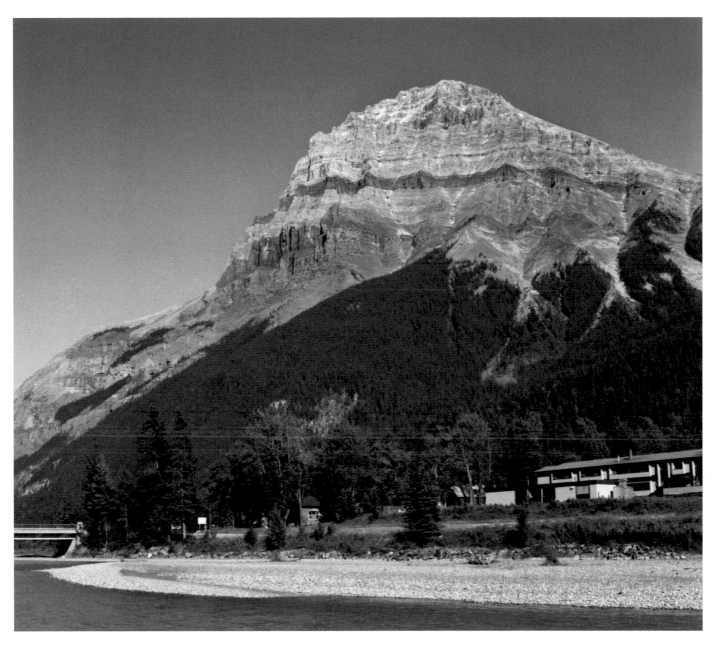

FIGURE 44: *Mt. Stephen, 2002*

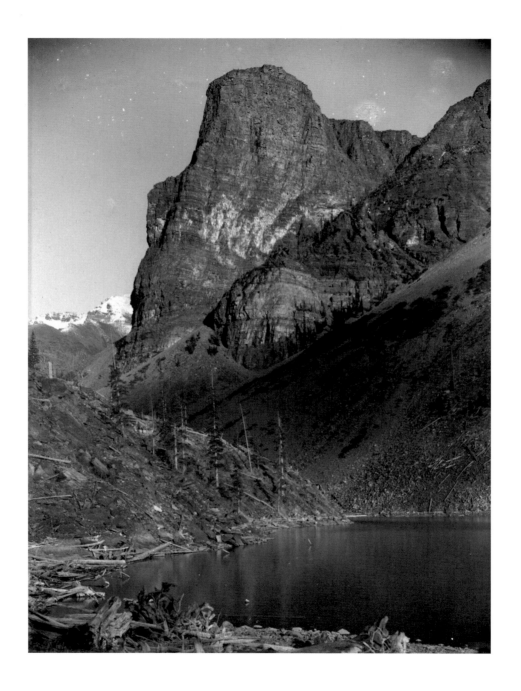

FIGURE 45:

Tower of Babel, 1902

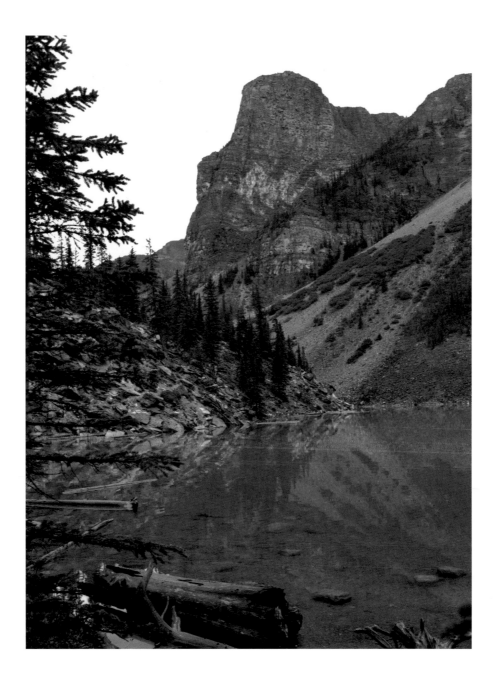

FIGURE 46:
Tower of Babel, 2004

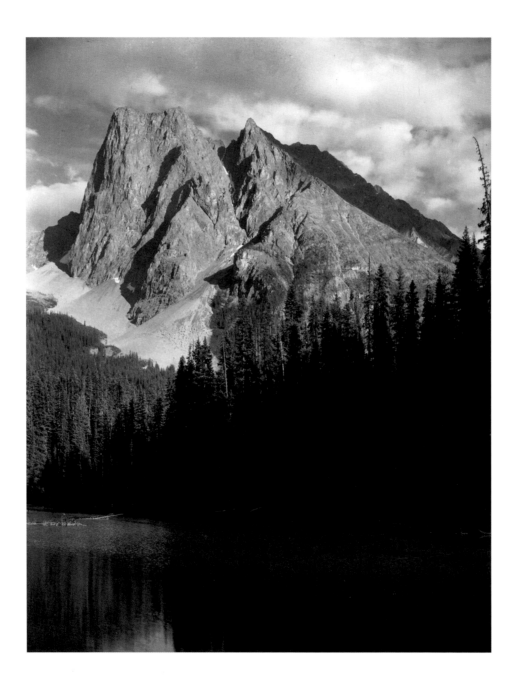

FIGURE 47:

Mt. Burgess, 1902

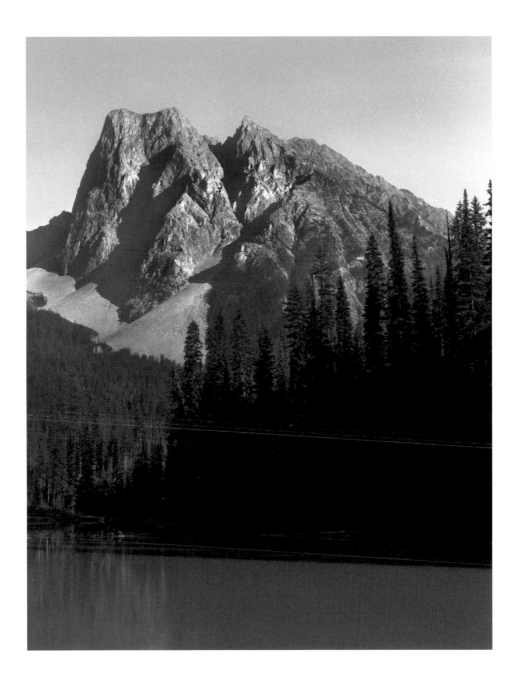

FIGURE 48:
Mt. Burgess, 2009

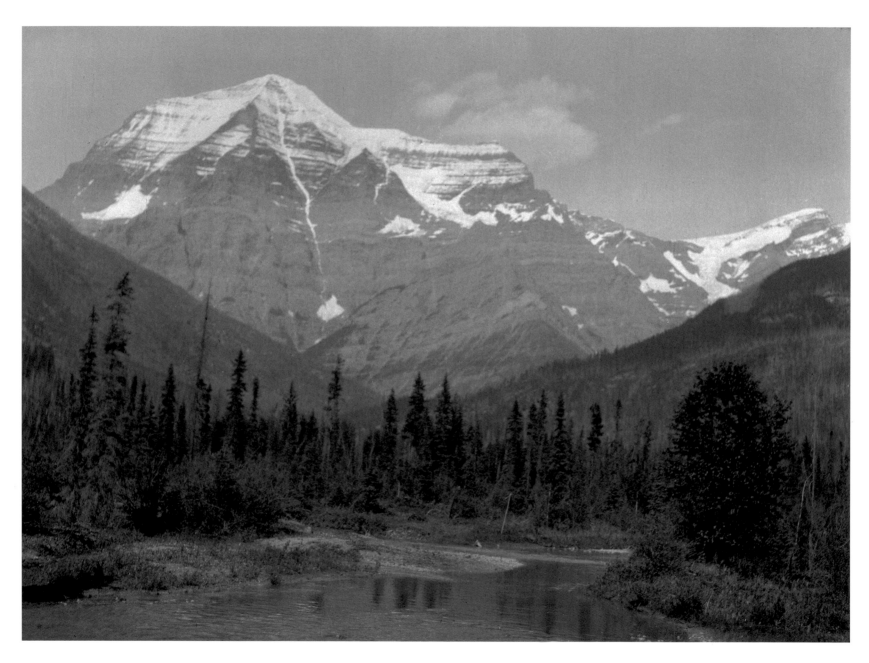

FIGURE 49: *Mt. Robson, 1913*

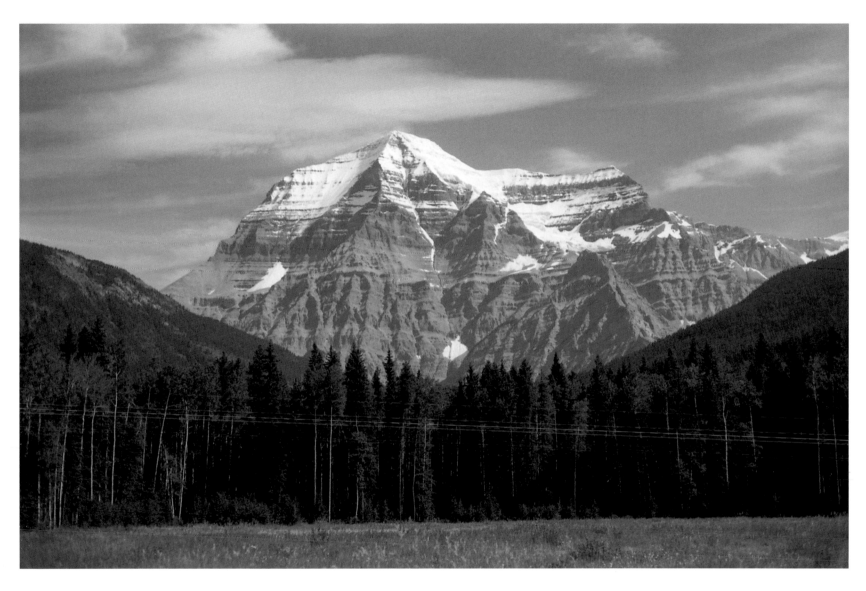

FIGURE 50: *Mt. Robson, 1997*

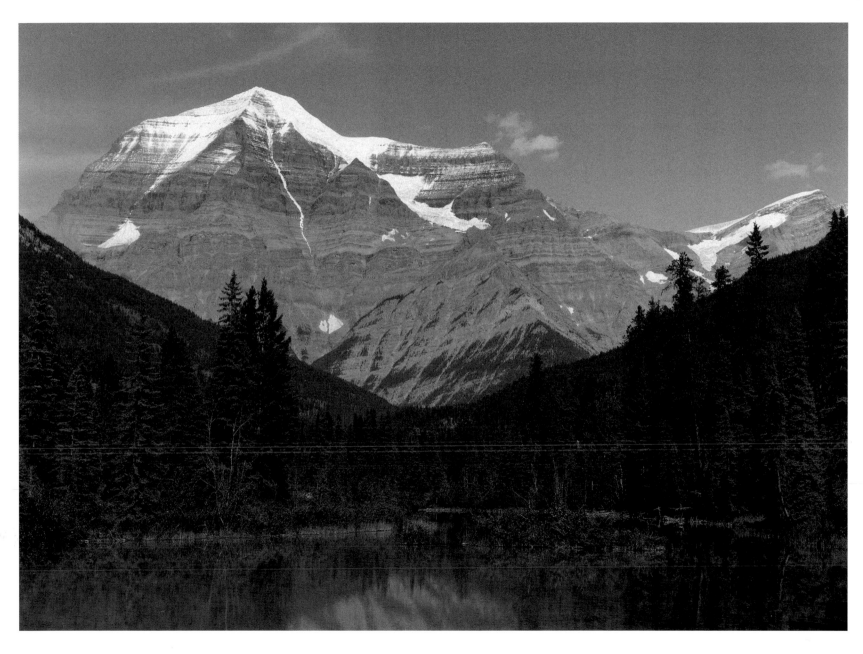

FIGURE 51: *Mt. Robson, 2013*

WATERFALLS

The first pair of pictures provides a clear sense of how glaciers and waterfalls may be linked. The importance of the role of glaciers in sustaining waterfalls is seasonal. Virtually all of the upland waterfalls in the Canadian Alps tend to be supported and sustained to some extent by glaciers. Glacial feedwaters may be particularly important in the late summer and early fall months, when the snowpack is largely gone and precipitation events are scattered and small. Also during this period, relatively warm ambient temperatures tend to accelerate glacier melting, which creates periods of maximum seasonal melt. By contrast, in the cold months, all water is frozen and the system tends to be relatively static. With the coming of spring and early summer, snowmelt tends to be the dominant source of water in streams. The appearance of waterfalls, particularly in late season, is partially a function of the rates of glacier melt. The volume of flow will increase during days (and years) when the melt is accelerating. The volume will decline when melt declines, either due to seasonality or to general recession and wastage of the glaciers themselves.

The underlying geology of Takakkaw Falls, shown in the first three image pairs, has not changed much in a century, and so the appearance of the falls tends to be governed by flow volumes. This is true also of Laughing Falls and Wapta Falls, both of which appear much the same today as a century ago. Twin Falls also looks very much the same. However, over time the volume of flow in one channel may predominate. This phenomenon is attributable to debris which clogs one channel or the other from time to time. There are casual records of one or the other channel being totally blocked. There is even an instance – many decades ago – in which it was reported that CPR crews used dynamite to restore the flow of one channel that was completely blocked.

The waterfalls remain as beautiful today as they were a century ago. Takakkaw was reachable in summer by horse-drawn wagon a century ago and can be accessed by automobile today. Access to the other falls requires moderate hikes today as was the case a century ago.

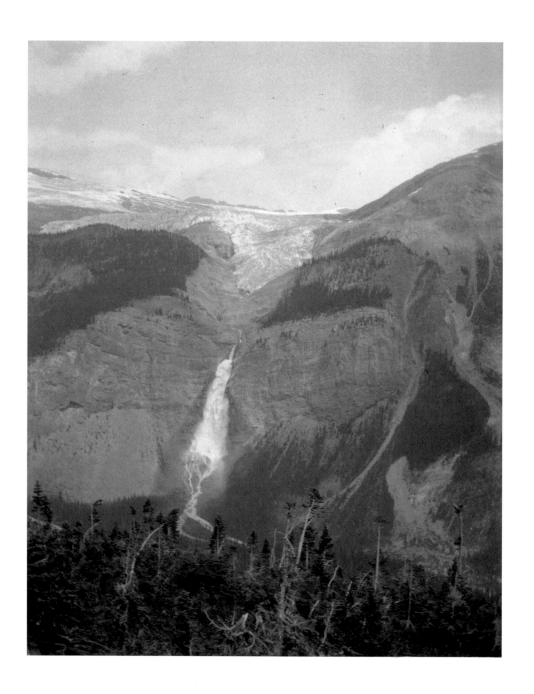

FIGURE 52:
Daly Glacier and
Takakkaw Falls, 1906

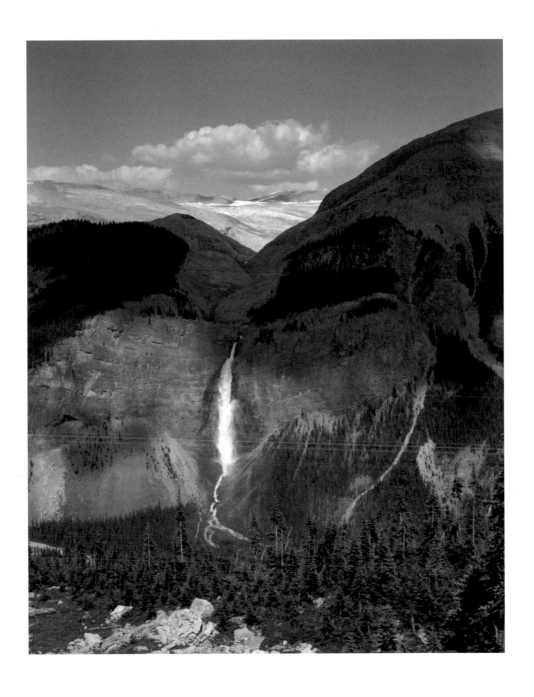

FIGURE 53:

Daly Glacier and

Takakkaw Falls, 2009

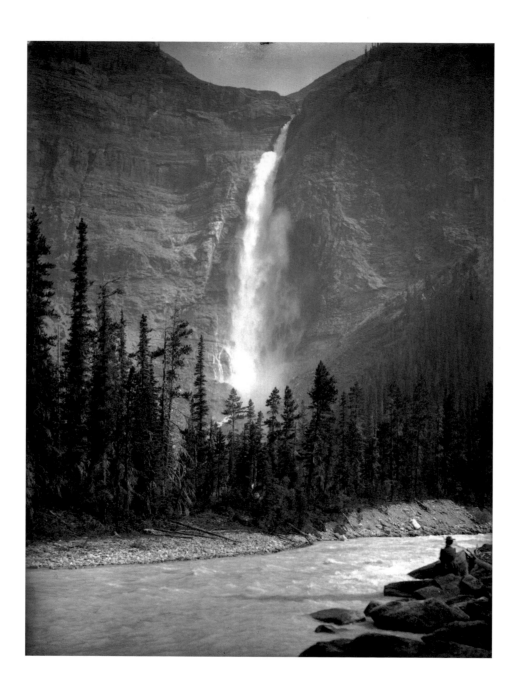

FIGURE 54:

Takakkaw Falls, 1901

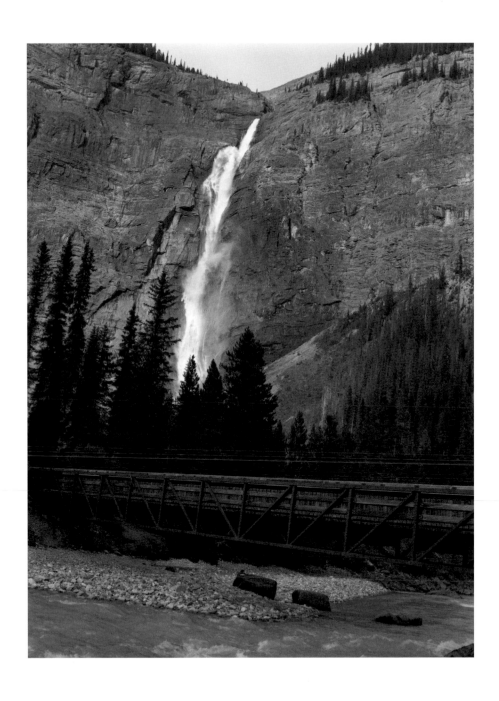

FIGURE 55:
Takakkaw Falls, 2002

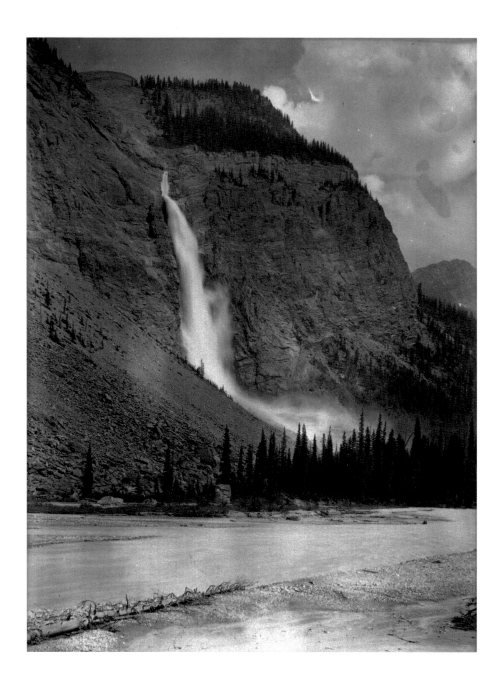

FIGURE 56:

Takakkaw Falls, 1906

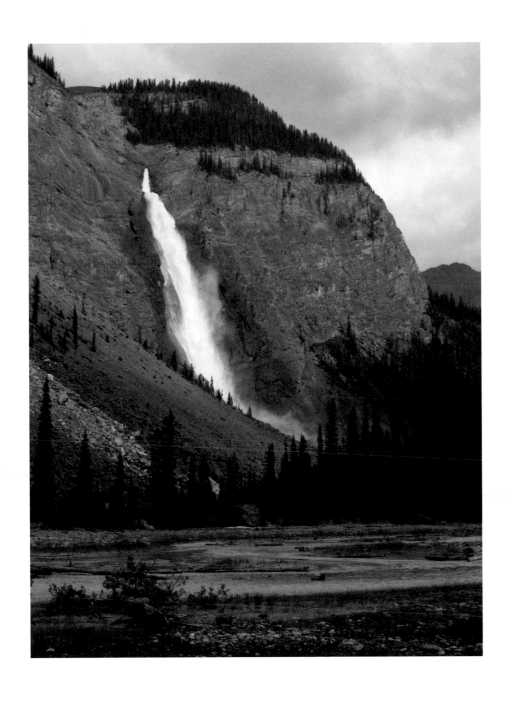

FIGURE 57:
Takakkaw Falls, 2002

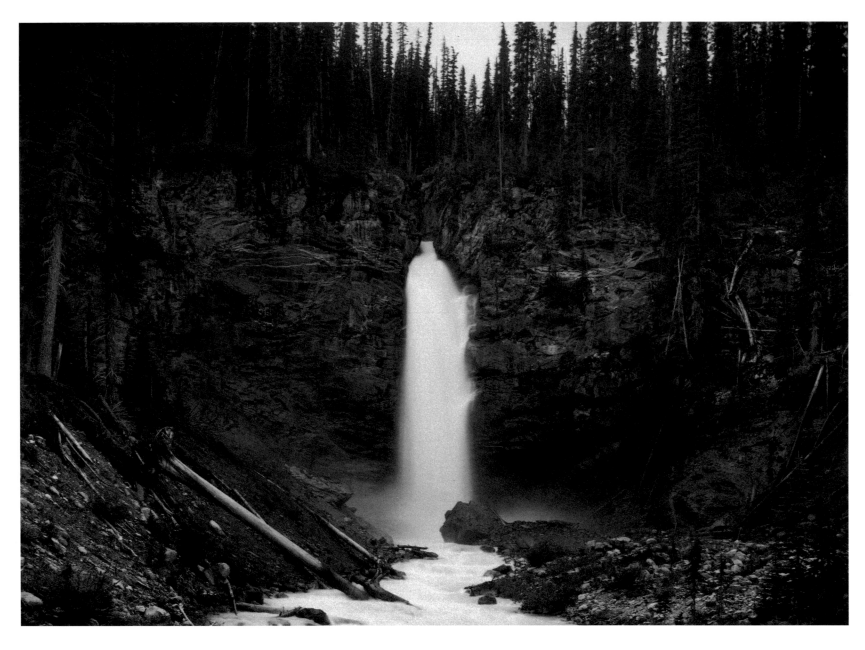

90

FIGURE 60: *Laughing Falls, 1906*

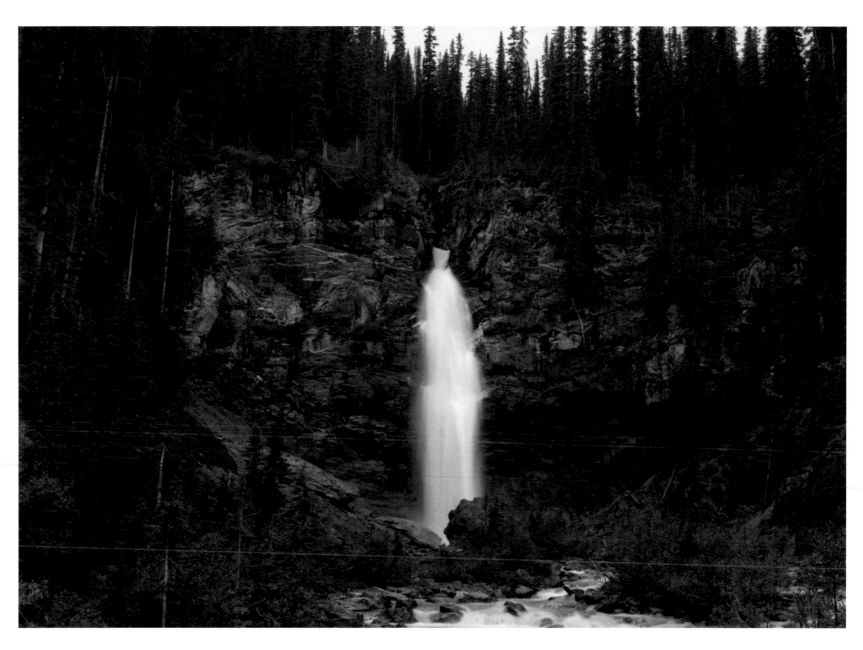

FIGURE 61: *Laughing Falls, 2008*

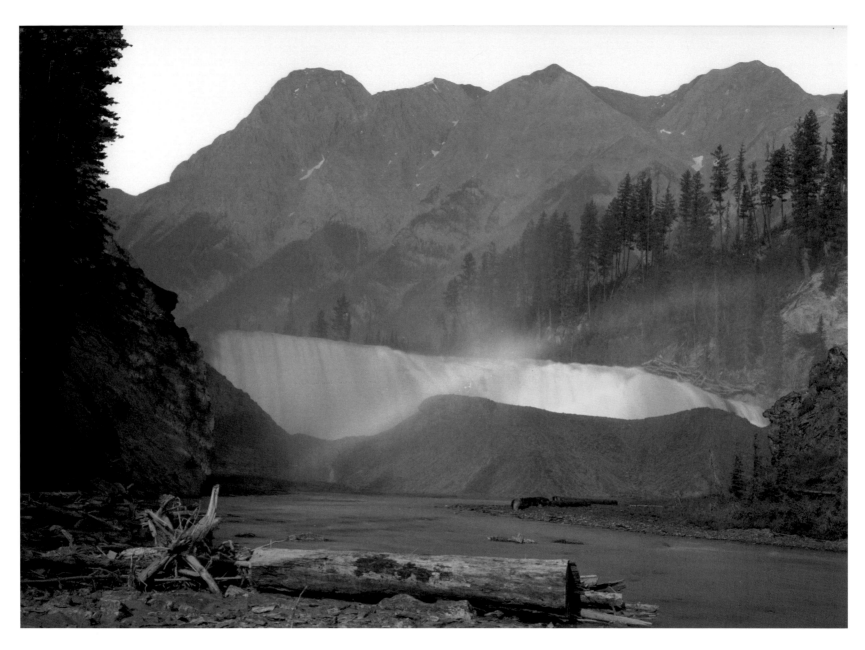

FIGURE 62: *Wapta Falls, 1904*

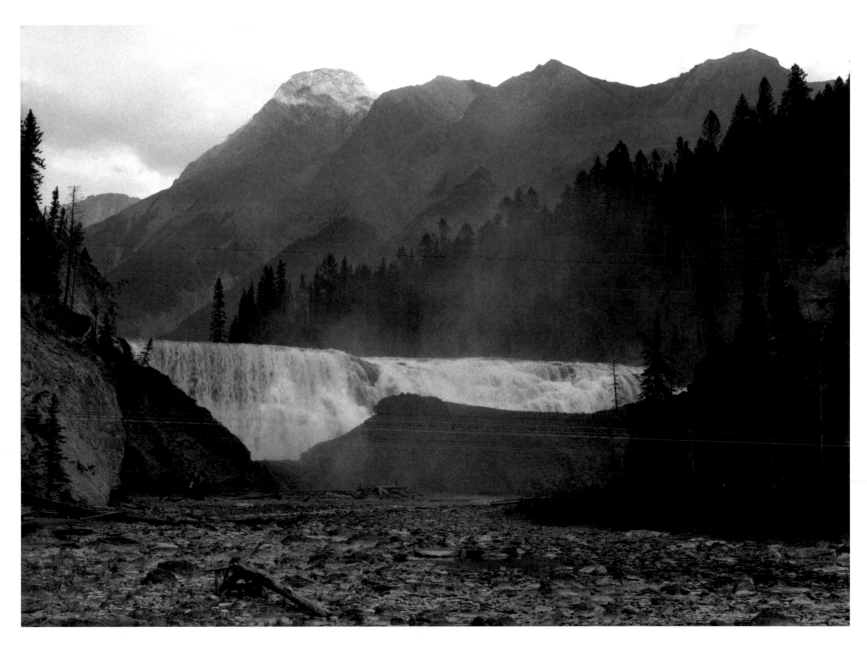

FIGURE 63: *Wapta Falls, 2005*

LAKES

It has now been more than 200 years since the lakes of the Canadian Rockies were first seen by non-indigenous people. At the time of those discoveries they were thought to be the most beautiful lakes in the world. They remain surprisingly unspoiled despite development along their shores. As the images show, they are still among the most beautiful lakes in the world. They are also among the most photographed.

These mountain lakes were formed as the ice sheets of the Ice Age receded. Glacial lakes are frequently found near the toes of receding glaciers and are largely composed of glacial meltwater. The mountain lakes of the Rockies are probably ancient glacial lakes. Their beauty stems not only from the dramatic and angular landscapes in which they are located, but also from their distinctive blue-green colour, derived from the "glacial flour" suspended in the water − fine-grained particles from the relentless grinding of bedrock by the glaciers. The beauty of these lakes was self-evident a century ago and remains so today.***

*** It should be noted that the photographs of Emerald Lake, Figures 72 and 73, feature a reflected image of Mount Vaux. Mount Vaux was named by James Hector in 1858, after a friend who had helped to secure funding for the Palliser Expedition. The friend, William Sandys Wright Vaux (1818–1885), was the resident antiquarian at the British Museum for nearly three decades. As far as is known, William Sandys Wright Vaux is unrelated to the Vaux family whose activities are discussed herein.

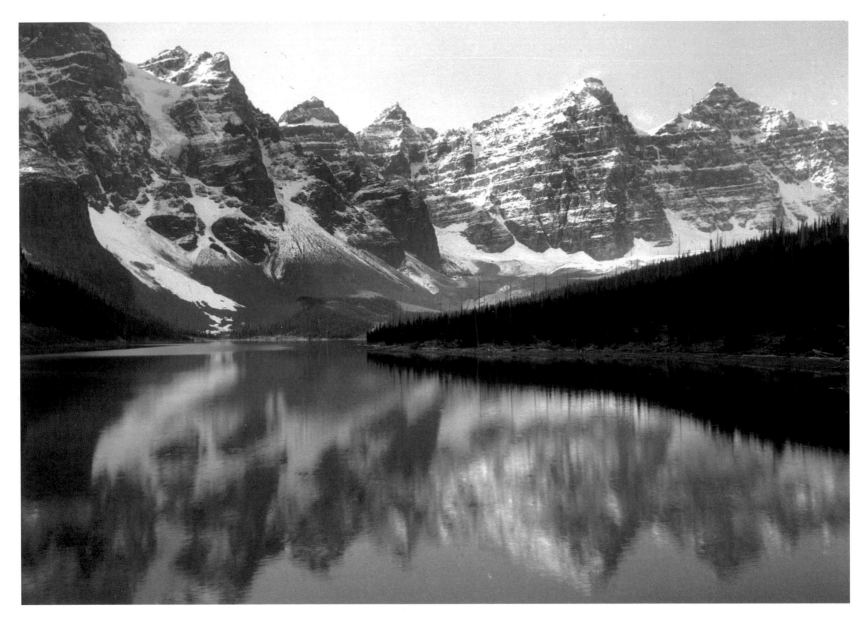

FIGURE 64: *Moraine Lake, 1902*

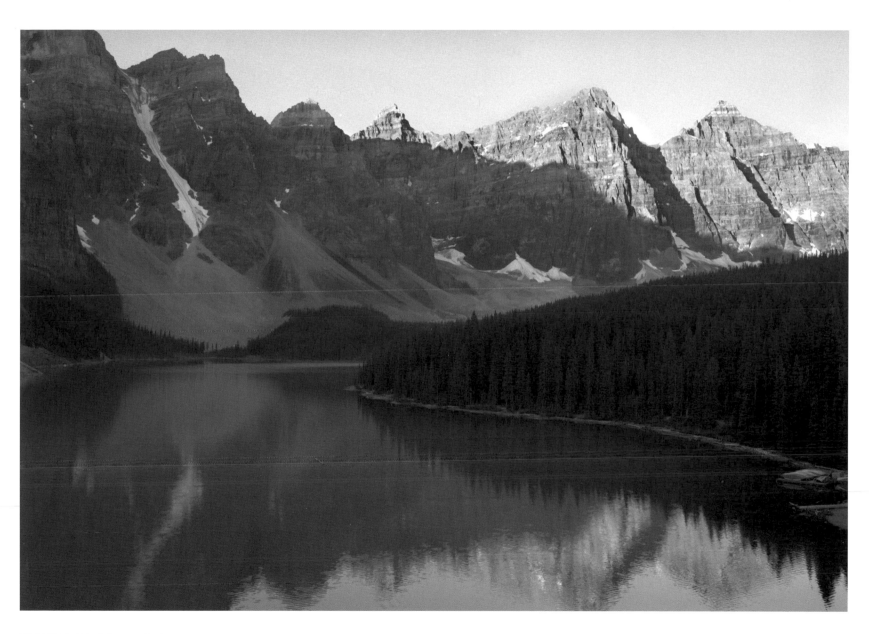

FIGURE 65: *Moraine Lake, 2002*

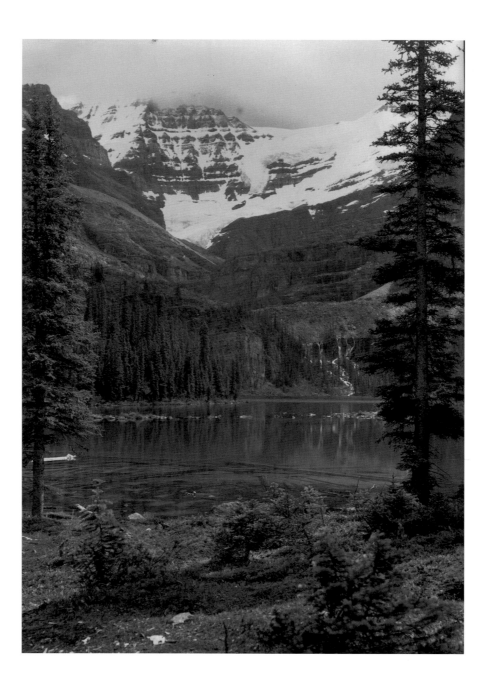

FIGURE 66:

Lake O'Hara, 1907

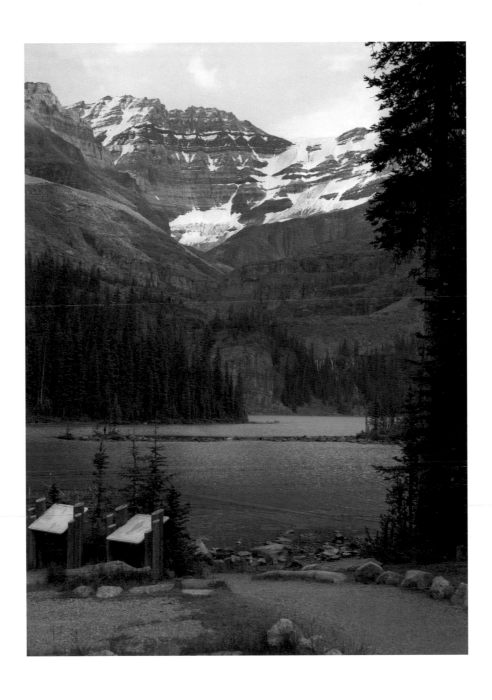

FIGURE 67:
Lake O'Hara, 2002

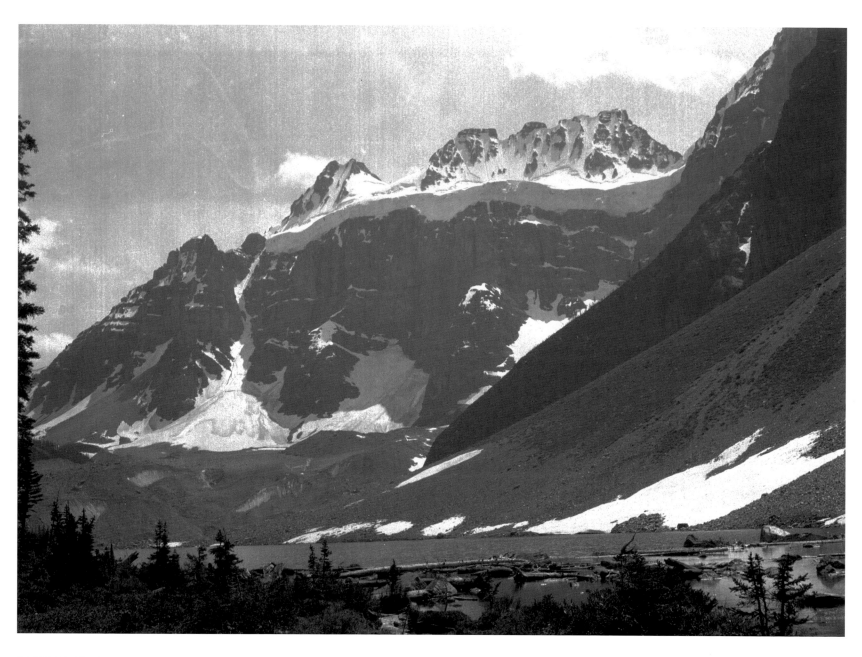

FIGURE 68: *Consolation Lake, 1910*

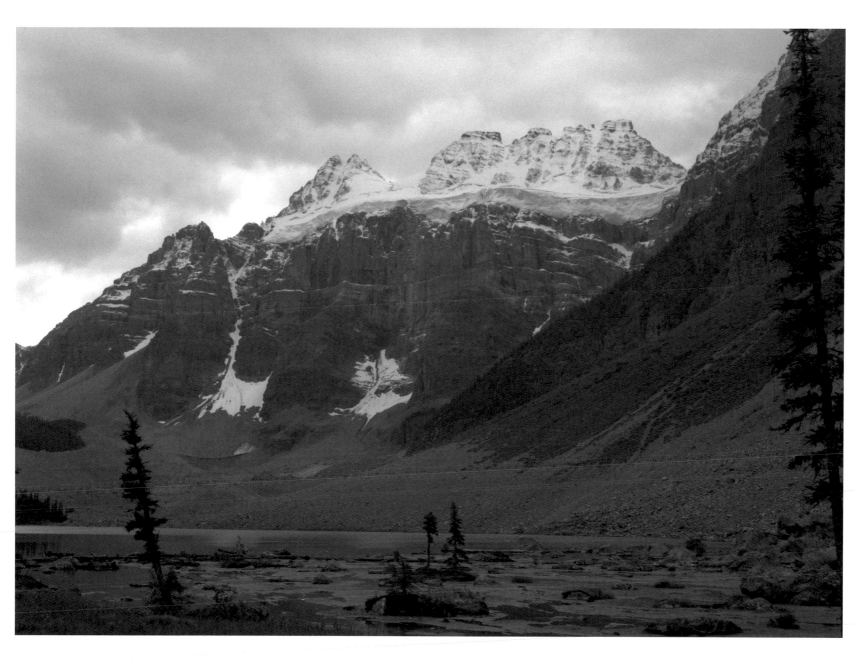

FIGURE 69: *Consolation Lake, 2008*

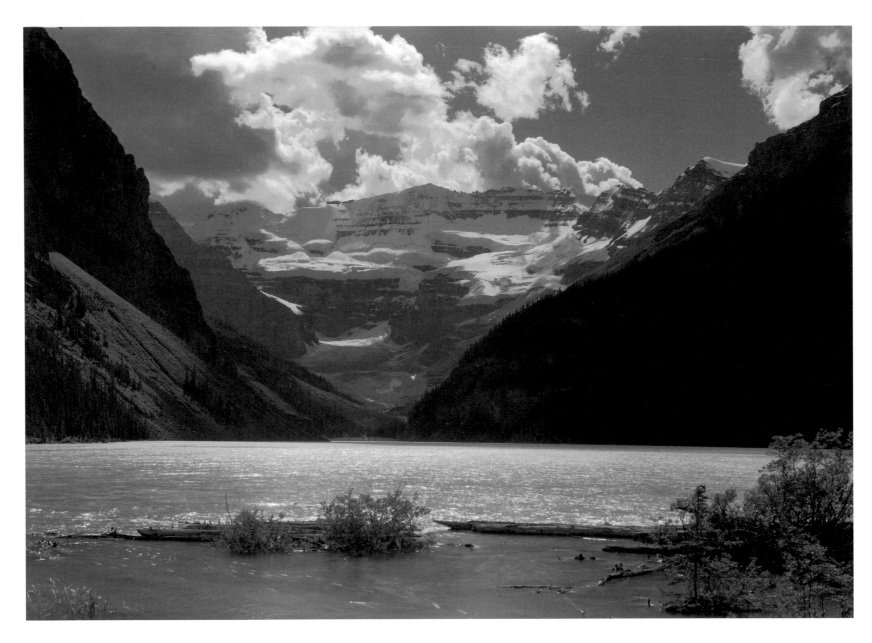

FIGURE 70: *Lake Louise, 1902*

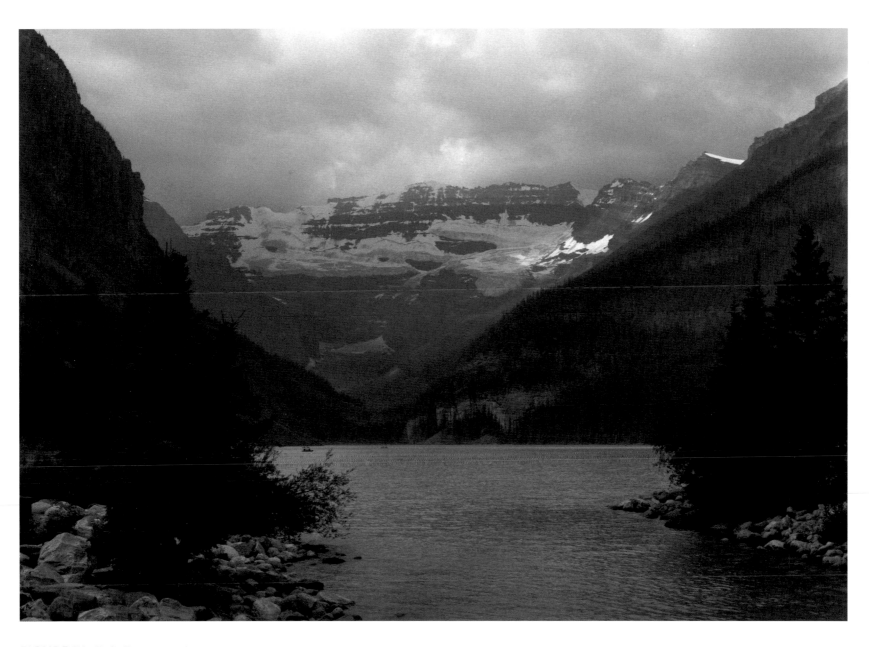

FIGURE 71: *Lake Louise, 2010*

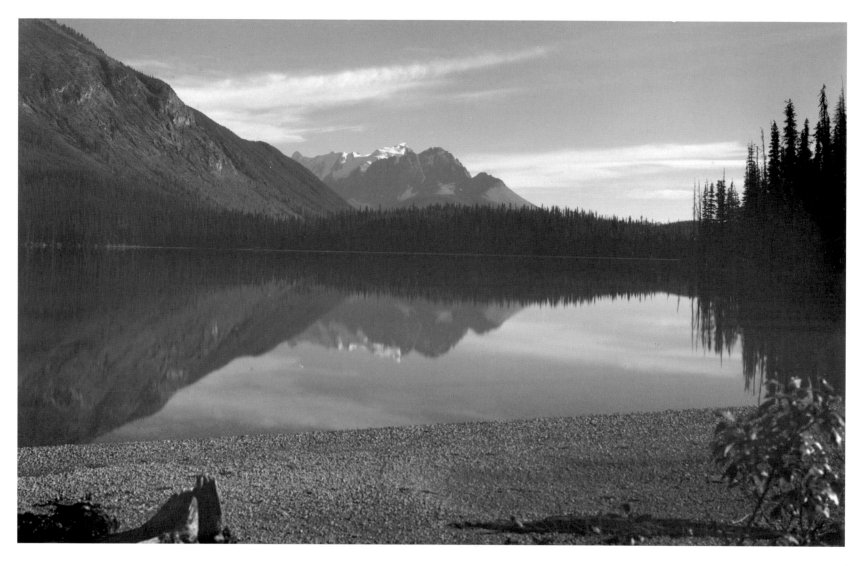

104

FIGURE 72: *Emerald Lake and Mt. Vaux, 1902*

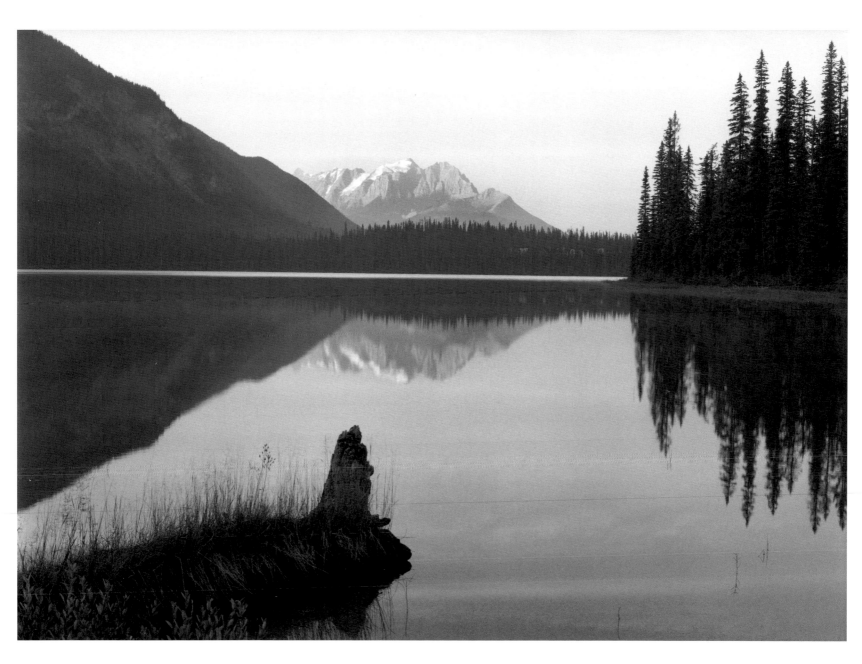

FIGURE 73: *Emerald Lake and Mt. Vaux, 2013*

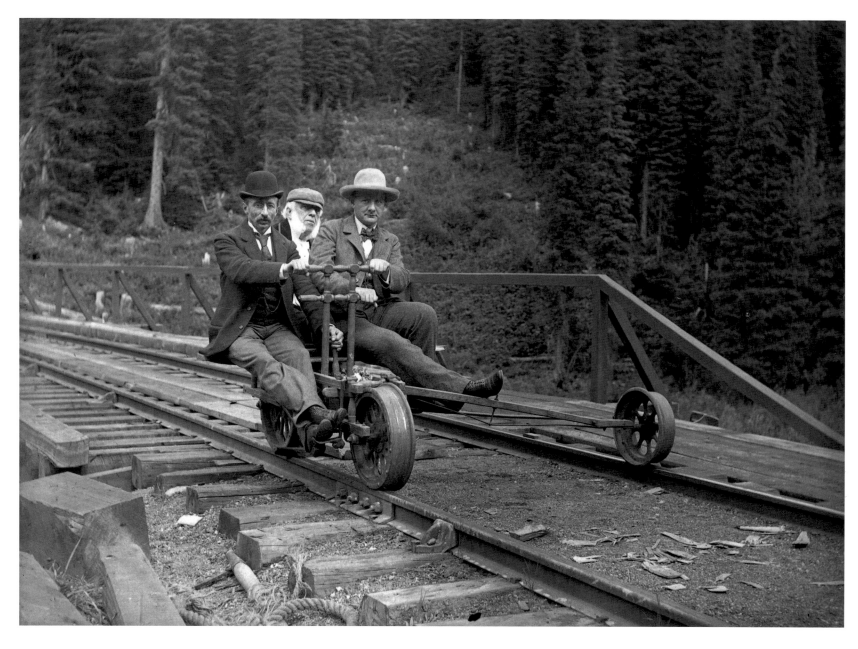

FIGURE 74: *CPR Assistant Superintendent Edward Duchesnay with Dr. Joshua Stallard (centre) and George Vaux IX (right), 1897*

n at Field, BC, 2003

FIGURE 75: *CPR Foreman John Gaffney, 2010*

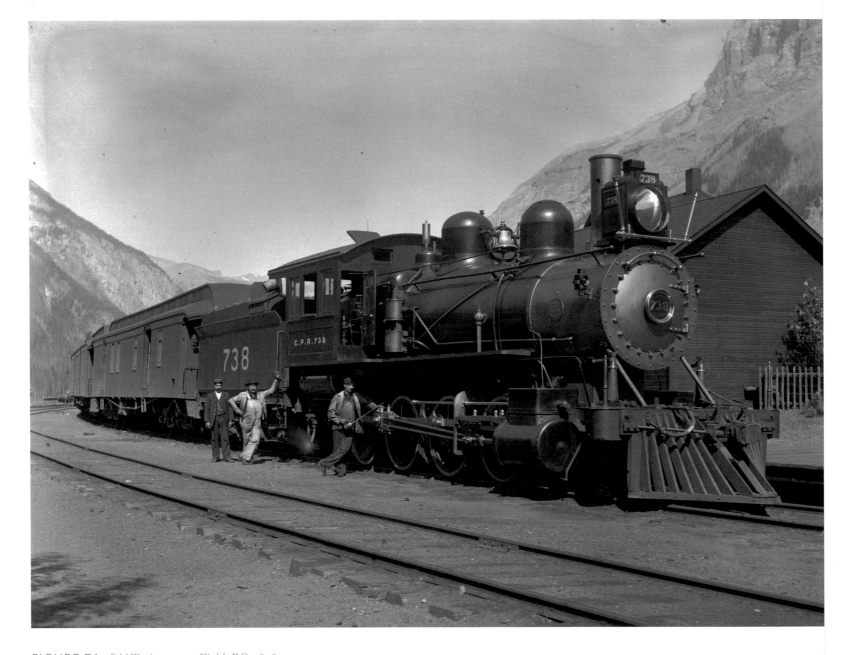

FIGURE 76: *Old Trainmen at Field, BC, 1898*

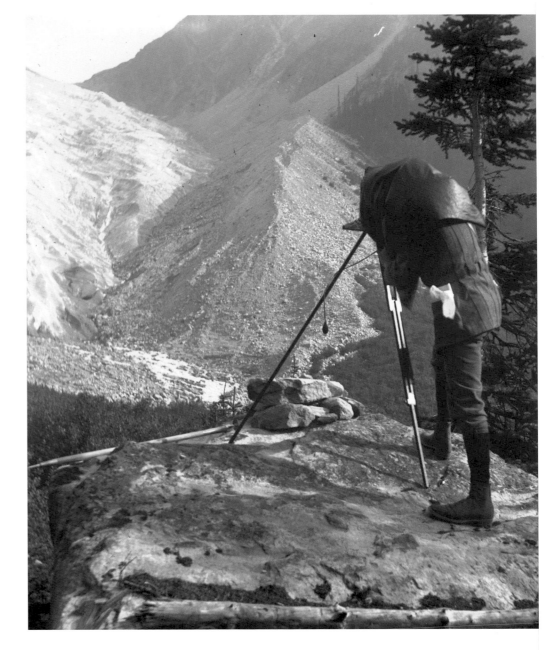

FIGURE 78: *William Vaux at Photographers' Rock, 1898*

FIGURE 81: *Mountain Guide Pierre Lemire, 2012*

FIGURE 82: *Interpreter and Mountain Guide Guy Clarkson, 2006*

Afterword

The photographic images in this volume suggest that, all things considered, the Canadian Alps have fared reasonably well over the last century. To be sure, the growth and increasing use of the rail and highway components of the major transportation corridor have created significant problems. Also, the geometric increase in the sheer number of visitors has put extraordinary pressures on the landscape. The glaciers have receded, but that recession has been a matter of degree, since the evidence seems to show that some recession would have occurred anyway, even in the absence of human activity on the planet. There has also been significant human development related to tourism and transportation. Yet, despite these events, the most striking conclusion that can be made about the visual changes of the past century is how much the landscape has remained the same. The mountains, lakes and waterfalls have fully retained their innate character of beauty, and major instances of landscape destruction are relatively few. Parks Canada deserves much of the credit for this state. Since the time when the Canadian Alps came under the protection of the Parks system, the agency has exercised its stewardship responsibilities well.

Past is unlikely to be prologue, however. Red flags abound and there are reasons for believing that much is going on beneath the visual surface. Much of that does not bode well for the future of the landscapes of the Canadian Alps. A grandchild who sets out to rephotograph the work included in this volume a century hence may justifiably wonder how the century recorded here could have witnessed so little change in the landscape given the magnitude of the changes that might be observed at the end of the following century. There are numerous signs of what the future may hold and they are not good.

Some of the changes that are underway or in the works are global in dimension. It is beyond the capacity of Parks Canada, a provincial government or the national government of Canada alone to respond to them. The problems are problems of the global commons. For example, Canadian scientists have discovered that the mountain lakes – both remote and nearby – are the most polluted portions of their respective watersheds. There is evidence that the contaminants are the result of atmospheric deposition and that some of them may have originated in the Far East. Attacks on western forests by pine beetles appear far worse than any that have preceded them. The cause is thought to be an absence of the prolonged cold periods (two weeks at $-40°c$) which historically have kept